IMAGES
of America

SOUTHINGTON

On *the cover*: **HARVEST TIME AT ROGERS' ORCHARDS, FALL 1948.** This picture, from the rear of the Rogers' salesroom, represents all the activities needed for a successful apple harvest. (Courtesy of the Rogers family.)

IMAGES
of America

SOUTHINGTON

Liz Campbell Kopec

ARCADIA
PUBLISHING

Published by Arcadia Publishing
Charleston SC, Chicago IL, Portsmouth NH, San Francisco CA

Printed in the United States of America

Library of Congress Catalog Card Number: 2007925901

For all general information contact Arcadia Publishing at:
Telephone 843-853-2070
Fax 843-853-0044
E-mail sales@arcadiapublishing.com
For customer service and orders:
Toll-Free 1-888-313-2665

Visit us on the Internet at www.arcadiapublishing.com

To Mark and Taylor

CONTENTS

ACKNOWLEDGMENTS

The pictorial history of Southington would not be possible without the contributions of many people. I am deeply grateful to Marie Secondo of the Barnes Museum for her kindness and willingness to look through the museum's collections for images for this book. I am also grateful to Kathy Connolly for loaning me the images that she has in her personal collection. The book benefited greatly from the loan of the outstanding cover image and other images provided by the Rogers family, and I am thankful that they allowed me to borrow them. Other individuals were also generous in searching their attics for photographs. My heartfelt thanks to Jimmy Angelone, Russ Andrus, Susan Hart, Warren Smith, and Russ Wisner.

I worked with original and published materials at the Southington Public Library and the Local History Room at the New Britain Public Library, and I thank the staffs for their helpfulness and willingness to locate and loan materials that I needed for this book.

I want to thank the historical society for the loan of its pictures.

I am especially grateful to several people, including Russ Andrus, Susan Hart, Dick and Virginia Hutton, Malcolm Orr, and Mary Degnan, for taking the time to talk to me and answer my questions. Their vivid recollections allowed me to bridge the gap between the Southington that I am familiar with and the Southington that they knew so well.

I would like to thank my editor, Dawn Robertson, and the staff at Arcadia for their help and patience.

Finally I would like to thank my husband, Mark, for his help and encouragement in this project.

INTRODUCTION

Southington was once part of Farmington. Samuel Woodruff, the first Colonial settler, came to the area to hunt and fish and by 1698 had moved his family to a site on the east side of Pleasant Street now occupied by DePaolo Junior High School. Gradually more families followed, especially after the 1722 South Division Survey was finished. The survey gave 84 prominent families of Farmington tracts of land in this area south of Farmington. It also set aside land for three major roads that still pass through the town today, West Street, Route 10, and East Street/Flanders Road.

In 1724, the residents petitioned the Connecticut General Assembly for permission to build a separate parish house, as the 11-mile trip to the church in Farmington was too difficult, especially in the wintertime. Permission was granted, and a new meetinghouse was built on Burying Ground Hill, which is now Oak Hill Cemetery. By 1779, the population was large enough for the Connecticut General Assembly to incorporate Southington as a separate town.

Originally the area was largely an agrarian society with a few small factories manufacturing combs, buttons, bellows, and other commodities scattered throughout the town. In 1825, hydraulic limestone used in the manufacture of Portland cement was discovered in the backyard of a farm on Andrews Street. A quarry was opened, and the kilns and mills necessary to process the cement were constructed. The business flourished for a number of years before the blue limestone was exhausted.

In 1828, the Farmington Canal opened with much flourish, promising residents a way to transport their goods to market, but the canal never reached its promised potential due to heavy debts and the constant breach of the sides of the canal causing extensive delays. When the railroad opened in 1848, the canal was eventually abandoned.

As the 19th century progressed, the Industrial Revolution arrived in New England powered by water. Entrepreneurs in Southington quickly harnessed the Quinnipiac River and the Eight Mile River, and manufacturing firms such as the H. D. Smith Company, Southington Cutlery, Atwater Manufacturing Company, J. D. Frost, Clark Brothers' Bolt, Aetna Nut, and other facilities sprang up along the banks of these rivers and beyond.

The factories needed a labor supply, and the waves of German, Italian, and Polish immigrants fulfilled this need. The Italians, many of them from the area of Castel Campagna in Italy, settled in close-knit neighborhoods near many of the factories. In an effort to preserve their culture and protect their interests in a sometimes-unfriendly environment, the Italians created their own social clubs, such as the Conte Antonio Laurengario (1897), the Society Saint Sisto Primo (1904), and the Sons of Italy (1910).

Recreation became important, especially to those working long hours six days a week. Lake Compounce located on the Southington-Bristol town line became an important destination for fun and recreation. Opened in 1847 by Gad Norton and Isaac Pierce, Lake Compounce is the oldest continually operating amusement park in the United States.

There were many important individuals who contributed to the growth of Southington. Jesse Olney wrote a geography that was second only in sales to Noah Webster's speller. Luman Andrews founded the Connecticut Botanical Society and collected thousands of botanical and archaeological specimens of the area that he contributed to the Springfield, Massachusetts, Museum of Natural History. Long before there were Polaroid pictures, Julian Florian invented an emulsion that made instant photography possible. Marcus Holcomb served as governor of the state of Connecticut. These are just a few of the people from Southington who made a difference in the quality of life for many.

In wartime, many Southington citizens served with honor. Two hundred and thirty volunteered for service in the Civil War. Others served and continue to serve their country whenever called.

Over the past 50 years, many changes have occurred in Southington. Most of the farms that once dotted the landscape are gone. The large factories are closed, replaced by smaller industries and retail businesses. Residential buildings have replaced most of the once-open spaces. The town of Southington refers to itself as the "City of Progress," and its landscape in the 21st century reflects that for better or worse.

One

SOUTHINGTON VISTAS

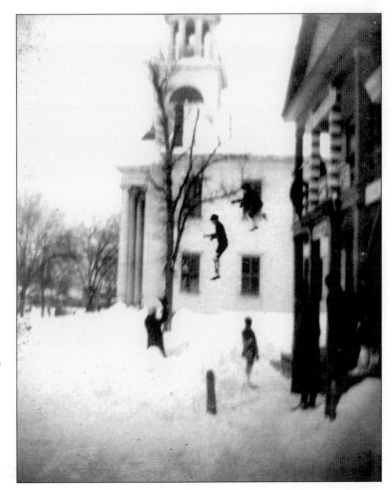

BLIZZARD OF 1888. Unidentified children enjoy leaping off the second story of the building that housed the post office and the newspaper on the south corner of Academy Hill and Main Street.

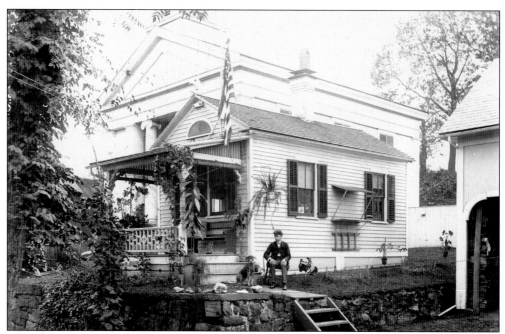

BRADLEY BARNES'S PLAYHOUSE, C. 1896. Bradley Barnes (1883–1973) sits in front of his own playhouse that was purchased and moved for him by his grandfather Amon Bradley (1812–1906). During his teenage years, Bradley entertained his friends and kept his carrier pigeons and angora rabbits here. The building formerly served as Gov. Marcus Holcomb's law office. Once located adjacent to the town green, the site is now a municipal parking lot.

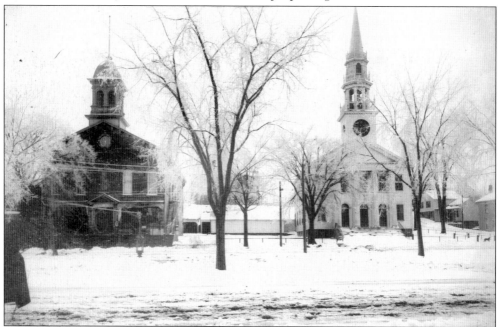

THE GREEN, C. 1900. Pictured in this early photograph are the town hall and the First Congregational Church. Of note are the early horse barns between the church and the town hall and the elm trees that once graced the green.

OLD TOWN HALL. On November 28, 1871, the townspeople voted 401 to 387 to build a town hall on land where the conference building for the First Congregational Church stood. Roswell Neal, Henry D. Smith, Julius B. Savage, Orson Stow, and Walter Merrell served on the building committee. They hired D. R. Brown as the architect and Samuel Woodruff as the contractor. The hall was dedicated on February 26, 1873.

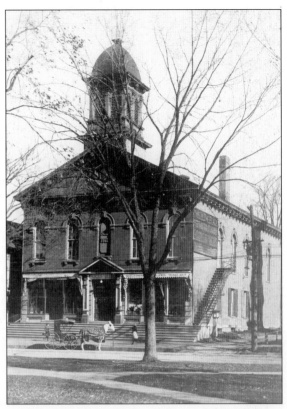

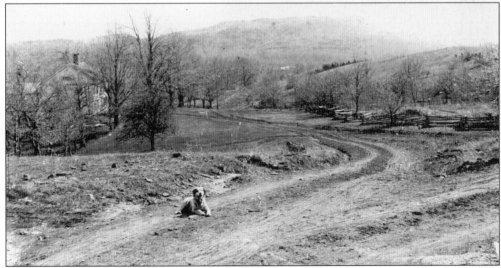

CORNER OF ANDREWS STREET AND WOODRUFF STREET, C. 1910. Most of the rural roads in Southington were often muddy and impassable until 1930, when a Southington resident, Louis G. Tolles, complained to the state legislature about the condition of these roads. A campaign titled "Get Connecticut Out of the Mud" was launched with an initial $3 million allocated for the improvements. Tolles became president of the Connecticut Rural Roads Improvement Association. The Florian Company of Southington manufactured a round tin bumper plate to promote the campaign.

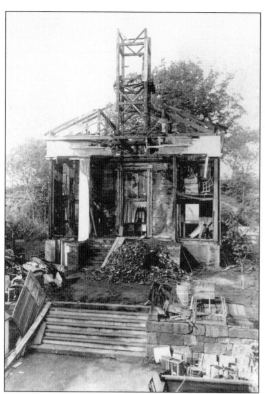

THE UNITARIAN CHURCH, 1906. Founded in Southington in 1841, the Unitarian church was erected in 1843 on land purchased from Amon Bradley. After an initial period of growth, the membership saw a steady decline and the church closed in 1853. Bradley reacquired the land and the building, and it was used for many years as storage by the Gould Store and later Kay's Furniture. The picture shows the devastation of the 1906 fire. The building was immediately rebuilt, only to be demolished in 1974 to make way for a municipal parking lot.

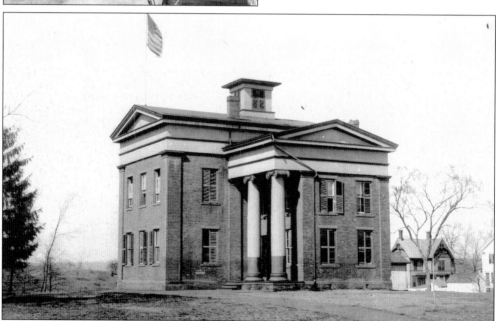

SALLY LEWIS ACADEMY. Built in 1848 with funds bequeathed by Sally Lewis, who died in 1840, and her cousin Addin Lewis (1780–1842), the school provided a high school education for those residents who could afford to attend. Later the tuition fee was abolished. The building itself was remodeled several times, and finally in 1896, the central portion of the structure was incorporated into a new and larger Lewis High School.

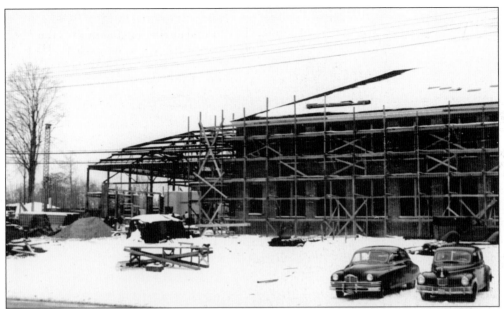

SOUTHINGTON HIGH SCHOOL, JANUARY 27, 1950. After World War II, as the population increased, the need for a new high school was evident. Construction began on July 11, 1949, and the E&F Construction Company completed the job for the September 23, 1950, dedication. The building is now the Derynoski Elementary School.

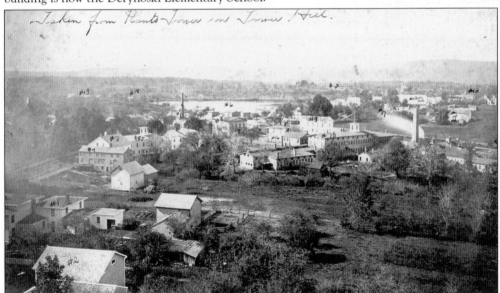

PLANTSVILLE CENTER, C. 1871. This picture of the village was taken from the observation tower that once stood on Plants' Hill. The Plant brothers were very much a part of the village that bears their name. In the lower left corner of the photograph are the barns of Amzi Perrin Plant, and next door is the home of his brother, Ebenezer H. Plant. The Plants' Manufacturing Company, which produced bolts from 1842 to 1874, is near the pond that was created by the brothers in 1847 when they dammed the Eight Mile River to create a source of power. Many of the buildings pictured remain, but Plants' Pond, Plants' Factory, their homes, and even their hill have disappeared.

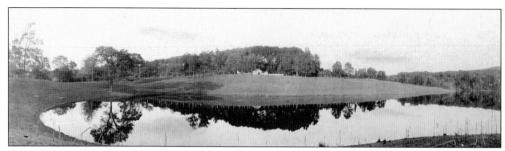

EAST STREET SCHOOL. Photographed from the southern shore of Sloper's Pond, the East Street School served the area residents for over 100 years. In 1942, the Monroe family moved the building to Jude Lane, where it was used for storage until it was demolished in the early 1990s.

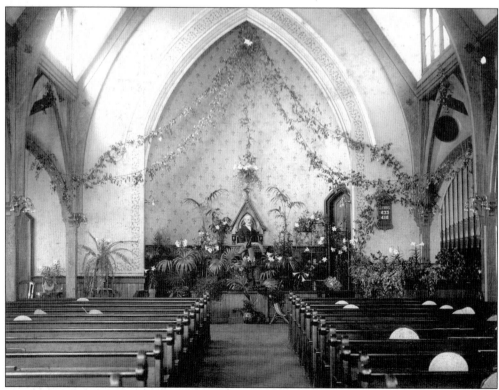

INTERIOR OF THE PLANTSVILLE CONGREGATIONAL CHURCH, PALM SUNDAY, C. 1915. Dr. John Brown Focht, pastor from 1908 to 1917, stands behind the altar. The church was organized by members of the Southington Congregational Church in 1865, with this building dedicated on March 21, 1867.

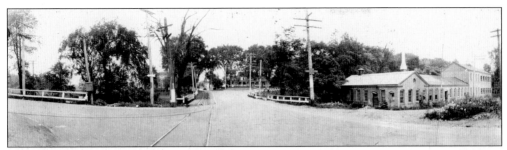

MERIDEN-WATERBURY ROAD AND OLD TURNPIKE ROAD, DICKERMAN'S CORNER, C. 1920.
This picture was taken prior to the construction of the Route 10 overpass in Milldale. The Dickerman homestead built by Sereno Dickerman (1806–1882) can be seen in the background. The Dickermans operated one of the largest dairy farms in Connecticut. When the Route 10 overpass was built, the house was moved across the street and still sits on Norton Street today. The Ellis Manufacturing Company pictured in the foreground was owned and operated by Frederick L. Ellis, his son Frederick, and later his grandson Russell. The company manufactured motorcycle parts, bicycle parts, and household hardware before its demise in the second half of the 20th century. A car wash now occupies the site of the former manufacturing facility.

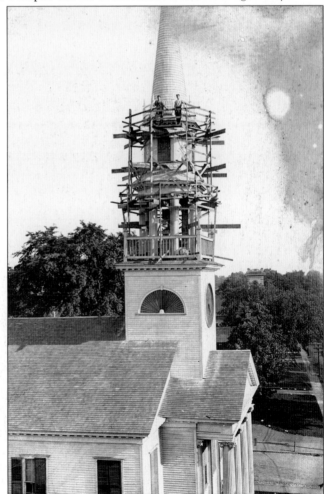

FIRST CONGREGATIONAL CHURCH, C. 1908. John W. Francis came to Southington as a carpenter in the 1880s. His sons Frederick N. Francis (1883–1965) and Howard P. Francis (1888–1953) are pictured here adding a railing around the steeple of the church. The cost of the entire project was $155. Frederick ran the Francis Brothers' Flower Shop on Douglas Street for a short time with his brother Charles but continued with his brother Howard as a carpenter until the 1950s.

15

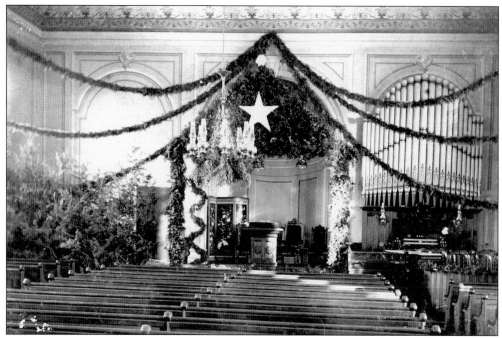

THE INTERIOR OF THE FIRST BAPTIST CHURCH, CHRISTMAS 1894. Built in 1833, the First Baptist Church was located on Main Street near the north end of the green. The pipe organ in the picture was donated by the wealthy industrialist R. A. Neal. On January 29, 1953, the building was destroyed by fire and was later rebuilt on Meriden Avenue.

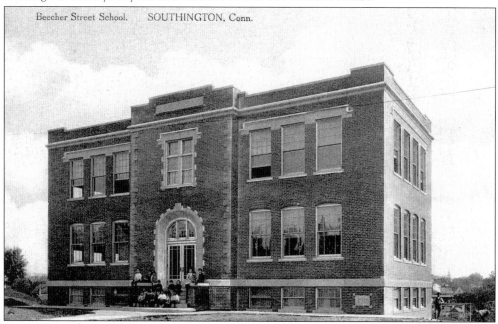

BEECHER STREET SCHOOL. As the conditions in the Southington schools grew more congested, the town decided to build a new Beecher Street School. The two-story brick building, designed by Walter P. Crabtree of New Britain, was completed in 1911 at a cost of $15,000. It now houses the board of education.

CORNER OF MERRILL AVENUE AND OAK STREET, C. 1900. Although now heavily populated, Oak Street and Merrill Avenue had many empty lots at the time of this photograph. The Orrs' home can be seen in the distance on the right. The Orrs' barns just below the house would be removed in 1913 to make way for the Orrs' new home built in the fashionable American foursquare style at 48 Oak Street. In the distance on the far right stands the back of the Bradley Barnes barn that still occupies the same site today. The young boy in the picture is Tommy O'Toole.

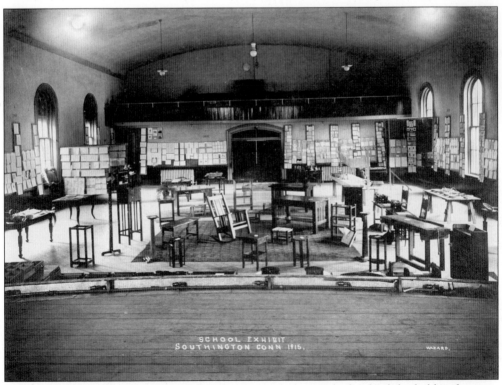

SCHOOL EXHIBIT, MAY 19, 1915. Pictured is the second annual school exhibit held at the town hall. It featured work completed by children in all grades throughout the town, including work done by the new manual training department at the high school.

ZION LUTHERAN CHURCH, BRISTOL STREET. The brownstone cornerstone was placed at the north corner of the Zion Lutheran Church on July 8, 1894. It contained a German hymnbook, a German Lutheran catechism, the New Testament, several coins, and newspapers. The church was expected to cost $1,000 to build. At the time of construction there were 25 members of the church. The Reverend C. O. Groos was pastor. The building now houses apartments.

PLANTSVILLE SCHOOL, C. 1900. The Plantsville School served the growing industrial area of Plantsville. By 1910, it became so overcrowded that the existing assembly room was converted into classrooms. During a period from 1900 until 1915, it reported the highest rate of closures for outbreaks of diphtheria and scarlet fever.

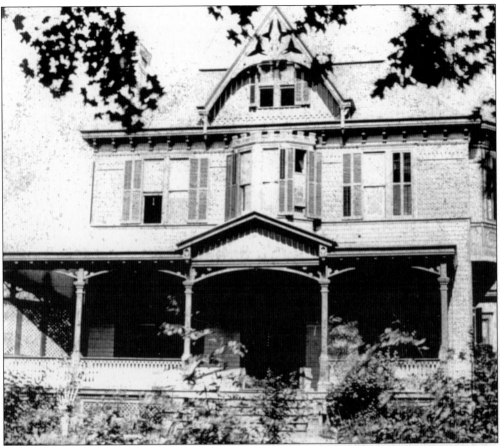

ST. THOMAS PARISH HOUSE. Developed from a glass slide, this is an early photograph of the St. Thomas Rectory on Bristol Street. The cornerstone was laid on August 24, 1884, under the direction of Fr. Matthew A. Hunt. Built in the Queen Anne style, the home served the parish until it was demolished in the early 1980s.

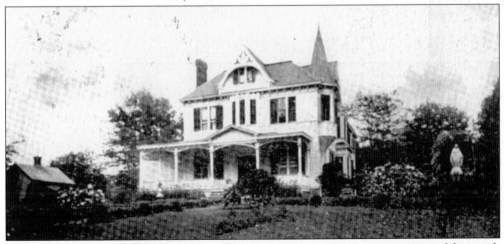

THE GROUNDS OF ST. THOMAS CHURCH. This picture shows a more sweeping view of the parish house and the surrounding landscape as it appeared in the early part of the 20th century.

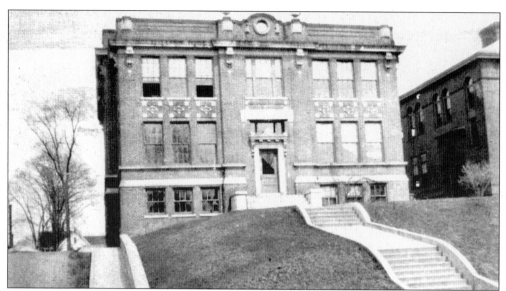

LINCOLN SCHOOL. The school was supposed to open its doors for the 1913 fall semester, but a strike hampered the opening until after Thanksgiving. In the early years, this school was one of the first to offer young men working in the local factories a chance to take mechanics and mechanical drawing on a Saturday morning. Many took advantage of the program. Lincoln School was also the sponsor of an agricultural program in which the children grew vegetables on a nearby three-acre lot and sold them to raise money for the school.

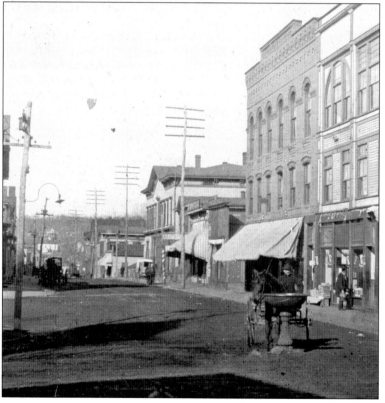

CENTER STREET, c. 1900. This is an early view of Center Street with the Oxley Block and the new Bishop Block lining the north side of the street. The Oxley Block, stripped of its third floor, survived into the later part of the 20th century, but the brick building, plagued from the start by mechanical and tenant problems, was gone by the late 1930s.

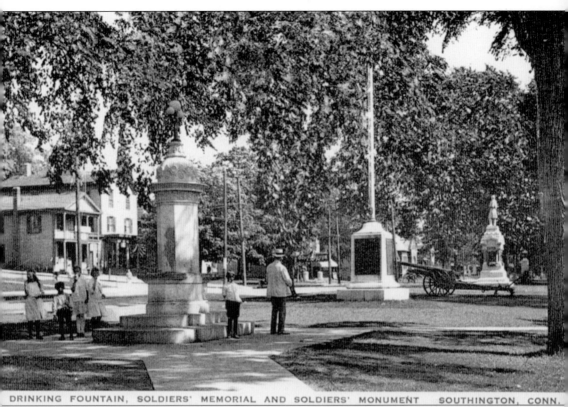

DRINKING FOUNTAIN, SOLDIERS' MEMORIAL AND SOLDIERS' MONUMENT SOUTHINGTON, CONN.

THE GREEN AND THE MONUMENTS, C. 1920. Although the Soldiers Monument was dedicated in 1880, other monuments were added to the green over the years. In the foreground is the Amon Bradley fountain, a gift to the town by Emma Bradley Yeomans Newell in 1918 in honor of her father. To the south of this monument is the Peck, Stow and Wilcox flagpole, dedicated in 1919. Bronze plaques on all four sides of the base feature the names of Southington veterans who served in every war up to and including World War I.

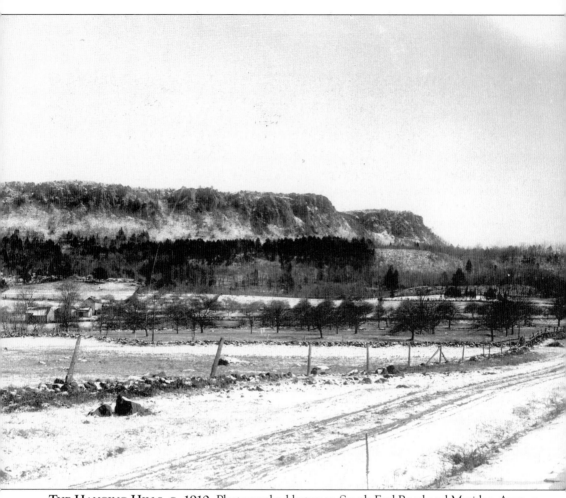

THE HANGING HILLS, C. 1910. Photographed between South End Road and Meriden Avenue, the area surrounding the Meriden-Waterbury Turnpike was just farmland at this time.

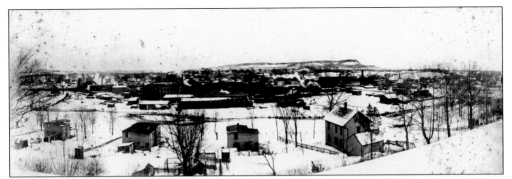

SOUTHINGTON CENTER, 1910. Photographed from the Center Street hill, the view reveals how industrialized Southington had become by the early 1900s. Peck, Stow and Wilcox; Southington Cutlery; and other smaller factories stretch from one side of the picture to the other.

MARION FIREHOUSE. The Marion Firehouse was once located on the southwest corner of Marion Avenue and the Meriden-Waterbury Turnpike.

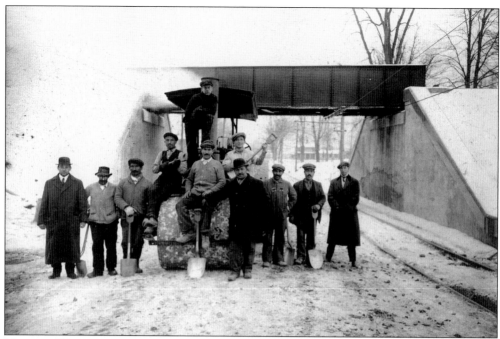

MERIDEN-WATERBURY ROAD, MILLDALE. Workers finish the site of the cut and the new railroad bridge that made it possible for the Green Line tramway to pass under the bridge on its way to and from Waterbury.

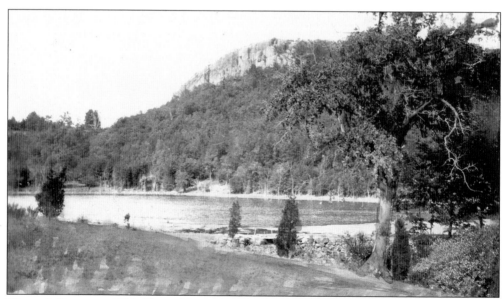

MOORE'S POND, C. 1920. Henry Moore, his brother Charles Martin Moore, and other farmers in the area dammed a small stream off Andrews Street to create a pond where they grazed their cows in the surrounding pasture. Until the area was developed, it was a popular picnic site with its spectacular view of High Rock.

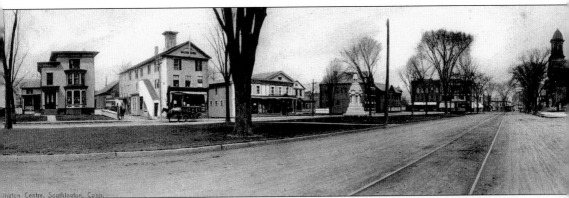

Ington Centre, Southington, Conn.

WEST SIDE OF THE GREEN. Pictured are, from left to right, Gov. Marcus Holcomb's house, Neal and Guernsey Store, Gould Store, Norman Barnes's house, the Southington National Bank, and the C. H. Bissell's Department Store. Although the bank remains, stripped of its fine architectural details, all the other buildings except the Holcomb house are now gone.

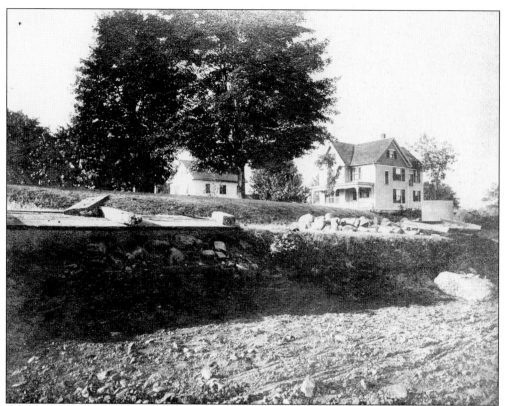

OAKLAND ROAD AND MERIDEN AVENUE. Around 1910, the Hemingway and Lewis Insurance and Real Estate Company began to develop one of the first subdivisions in town called Oakland Park. Pictured are the improvements to the area to support the development. The white house in the background is the former home of the Reverend Frederick Stevens, minister of the First Congregational Church. He left his wife, the former Mary Gridley, and their young child Doris and returned to his parents in Wisconsin.

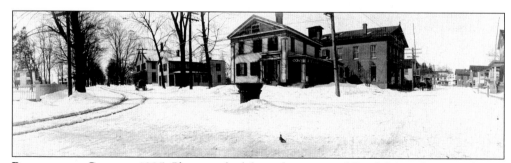

PLANTSVILLE CENTER, 1885. Photographed from the corner of South Main Street and West Main Street, the scene shows the early commercial development of Plantsville along West Main Street. The house in the center of the picture still stands but is greatly altered.

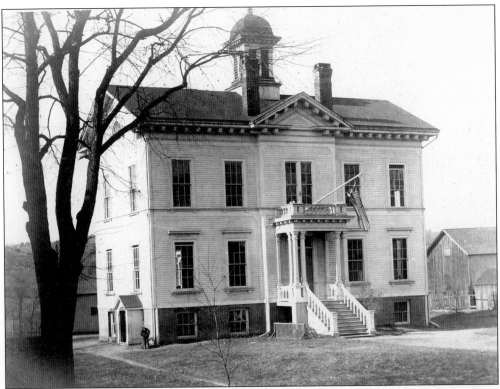

NORTH CENTER SCHOOL. Built in 1875, North Center School served as an elementary school until 1959.

MARION AVENUE. Pictured is a winter view of Marion Avenue looking north at School Street. The early Marion schoolhouse is visible on the left side of the photograph.

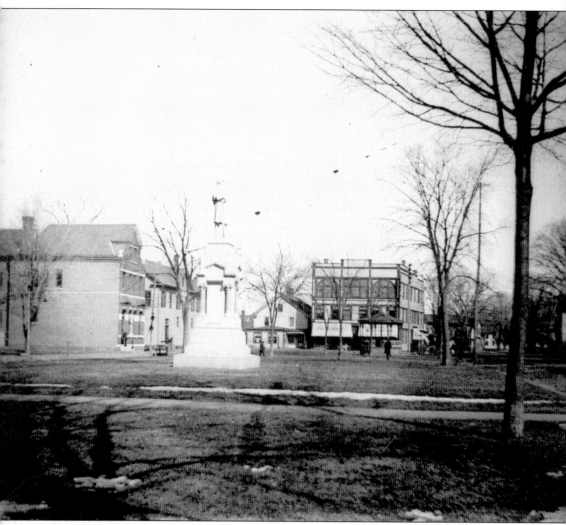

THE GREEN, C. 1893. Pictured is the Southington green before the Amon Bradley monument and before the house that J. B. Savage owned next to the Oxley building was torn down and replaced by a three-story brick building. J. B. Savage's building was the last of the residential buildings to survive in this growing commercial area.

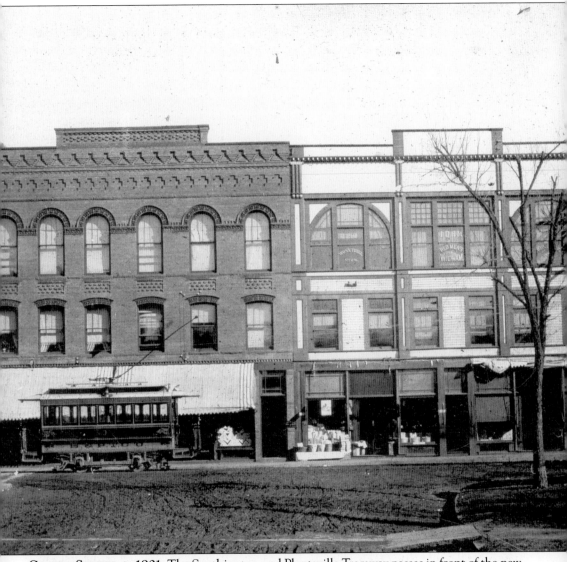

CENTER STREET, C. 1901. The Southington and Plantsville Tramway passes in front of the new Bishop Block built in 1895 by A. J. Bishop. Bishop married Emma, daughter of J. B. Savage, and acquired the property when Savage died in 1894. The new three-story building housed a variety of tenants over the years, including the Orr and Judd Shoe Store. Eventually Alfred Oxley, owner of the adjoining commercial building, bought it. It was torn down in the 1930s to make way for a First National Store.

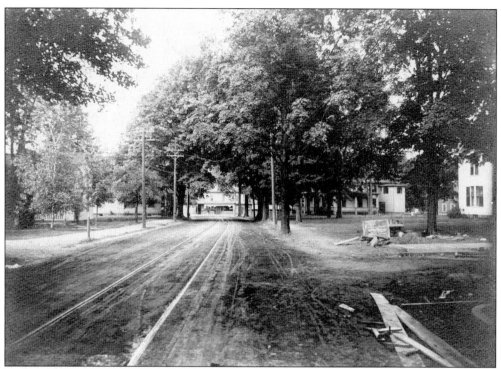

PLANTSVILLE, C. 1800. This photograph was taken looking north on South Main Street at the intersection of Hillside Avenue.

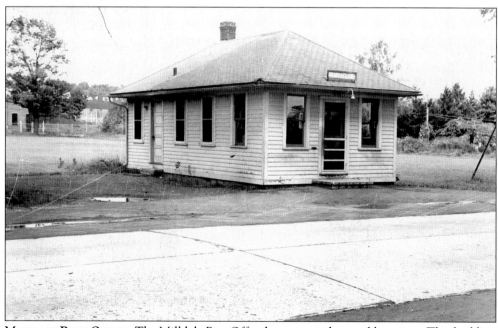

MILLDALE POST OFFICE. The Milldale Post Office has occupied several locations. This building was opened in 1922.

REMNANTS OF THE FARMINGTON CANAL. Chartered in 1822, the Farmington Canal was opened from New Haven to Southington in 1828. Many thought that the canal would prove a boon for businesses by providing them with a way to transport their goods. However, the canal was never a success. Flooding, breaches in the banks along the canal causing long delays, and the coming of the railroad all served to insure the failure of the project.

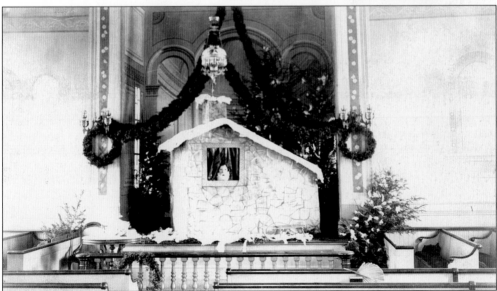

FIRST CONGREGATIONAL CHURCH, C. 1910. Churchgoers were treated to elaborate decorations during this Christmas season.

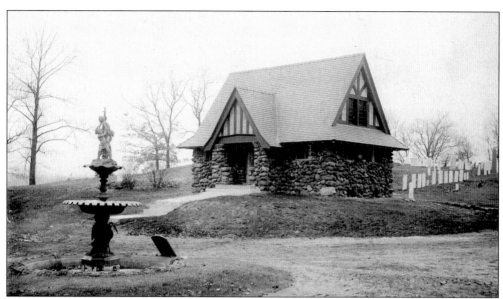

BRADLEY, YEOMANS, BARNES MEMORIAL CHAPEL, 1907. Located at the entrance to Oak Hill Cemetery, the chapel was donated by Julia Bradley, Bradley Barnes, and Emma Bradley Yeomans Newell in memory of several family members. Merit Woodruff donated the fountain that at one time graced the circle in front of the chapel. He gave it in memory of his wife and son. Oak Hill is the oldest burying ground in town, dating from 1733. Its markers range in style from the simply carved brownstone markers to the magnificent neoclassical monuments. The grounds reflect a who's who of Southington's past.

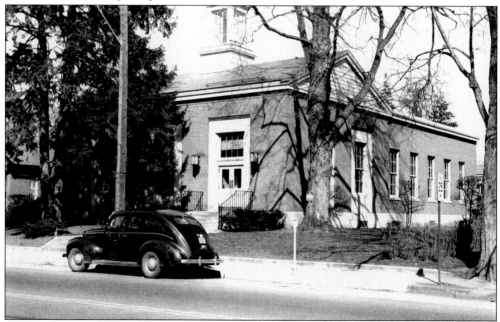

SOUTHINGTON POST OFFICE. After several locations, the Southington Post Office dedicated a new building at 125 Main Street on June 15, 1940. The large mural that graces the interior west wall was done by Ann Hunt Spencer. It depicts both industrial and agricultural vistas, reflecting the roots of the town. At the time of the dedication, John J. O'Keefe was postmaster.

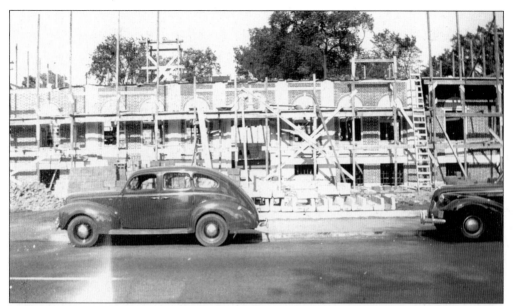

CONSTRUCTION OF THE TOWN HALL, MAY 1941. As the town grew during the first part of the 20th century, the need for a new town hall became evident. A building commission was formed with Charles Crowley, J. Robert Lacey, James Simone, George Bansemer, and Lindsay Hutton as members. A site was chosen on the corner of Academy Hill and Main Street. William T. Towner and Guy Francis Lamb were the architects, and Felix Buzzi and Sons were the general contractors. Work proceeded quickly with the dedication held on December 13, 1941.

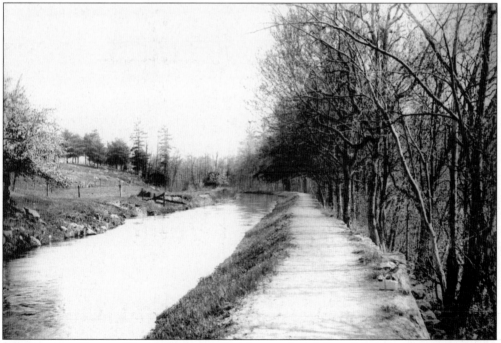

FARMINGTON CANAL. This picture was taken from a glass slide and shows a much clearer view of the canal and towpath than can be seen today. The remnants from the canal lasted much longer than the ill-fated business venture.

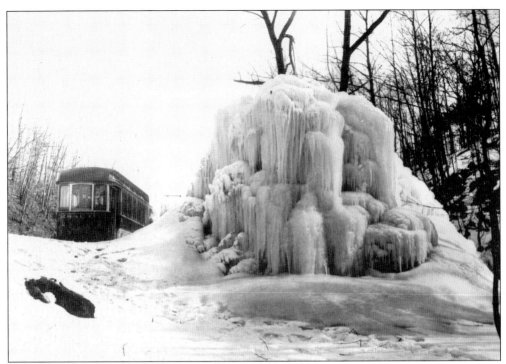

Tramway in Winter, c. 1920. The Green Line tramway makes its way over the treacherous stretch of Southington Mountain. The ride was picturesque but dangerous.

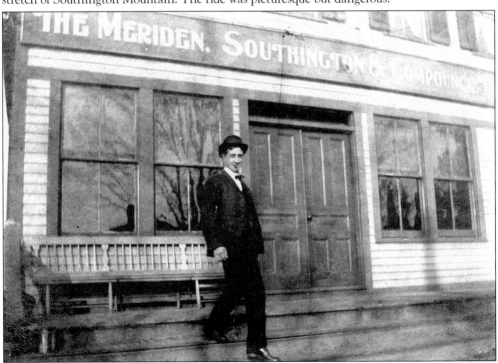

Milldale Waiting Room. George Church descends the stairs of the waiting room at the Milldale carbarns. The trolley barns and the waiting room were demolished in the 1980s.

THE GREEN, C. 1885. This is an early picture of the green with the First Baptist Church featured on the right-hand side of the picture. The Barzillai Lee and J. B. Savage homes still occupied the corner of Center Street and Main Street before the area became commercialized in the latter part of the 19th century.

THE EAST SIDE OF MAIN STREET, C. 1925. An unidentified woman strolls down Main Street with her children. The Methodist church is the building on the far left, with the Southington Savings Bank next, followed by the large J. B. Savage house that would be torn down to make way for the new post office dedicated in 1940. None of the buildings pictured here remain today.

Two

PASTIMES AND ASSOCIATIONS

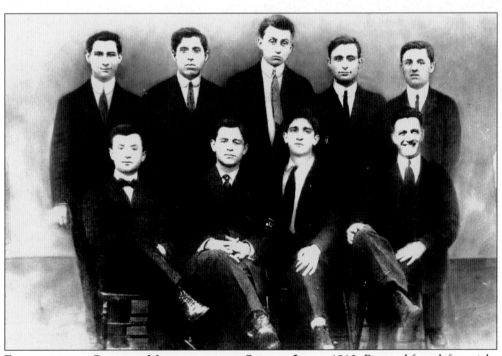

FOUNDERS AND CHARTER MEMBERS OF THE SONS OF ITALY, 1910. Pictured from left to right are (first row) Michael Maddelena, Vincent Salvatore, Michael Manware, and Charles Cari; (second row) Sisto Salvatore, Angelo Riccio, Michael DiNello, Alphonse Salvatore, and Robert Morelli. The society promoted Italian culture and heritage and helped recent immigrant families establish themselves in town.

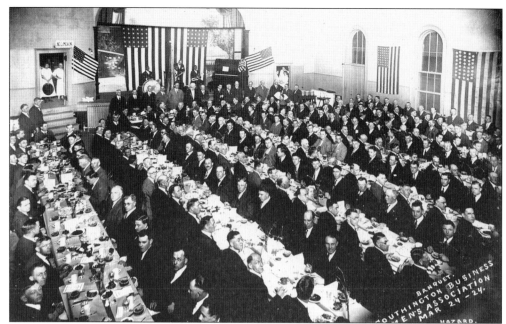

THE SOUTHINGTON BUSINESS MEN'S ASSOCIATION, MARCH 24, 1924. Photographed on the second floor of Southington's original town hall, the turnout for this annual dinner shows the importance and growth of industry and business in the town at the time. The hot topic that night was the improvement of the town's fire equipment. The association was the successor to the Merchant's Club, founded in 1887 by Winfield S. Gould, Charles W. Bushell, William Hutton, and Edwin Lewis. In 1938, the organization became the Southington Chamber of Commerce.

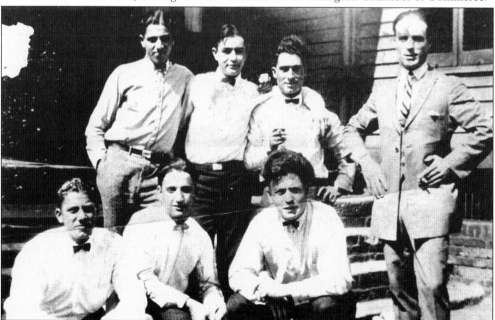

SONS OF ITALY STRING BAND, 1922. Shown here are, from left to right, (first row) Louis DeAngelo, Victor Leardi, and Nicholas Maemza; (second row) Andrew DeAngelo, Anthony M. Egidio, Tony Mezzacoppa, and Joseph Nardi, bandleader

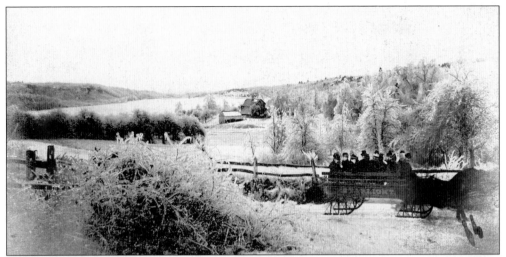

A Winter Excursion aboard the Starlight around Shuttle Meadow Reservoir Near Rogers' Orchards. The Dunham Farm can be seen in the distance. The farm, built before the Revolution, was removed in the early part of the 20th century. On the eastern shore of the reservoir, not visible in the picture, was the Lake House, a popular Victorian resort that provided music and dining to local residents.

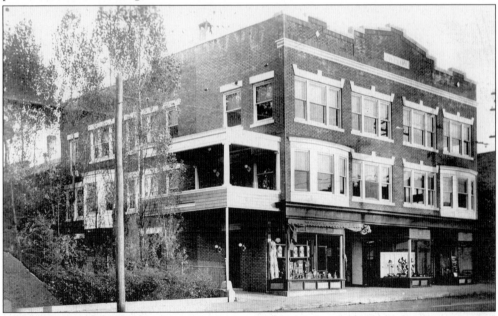

The Coleman Theater. On January 16, 1914, Dorr O. Coleman and his wife, Hattie, opened the first movie theater in Southington. Dorr, a postal employee, already owned a livery stable on Berlin Avenue in what is now the parking lot of a bank and would soon open the first laundry in town behind this theater. In 1922, as the movie business flourished, the Colemans hired Michael Gura, a local builder, to enlarge the existing theater and add shop space on the ground level and apartments on the second and third floors. This photograph was taken soon after these improvements were completed. In subsequent years, the theater was known as the Colonial, the Abby, and finally the Showkase before it closed in 1981. Today the building is known as Abby Park and houses offices, retail space, and a career institute.

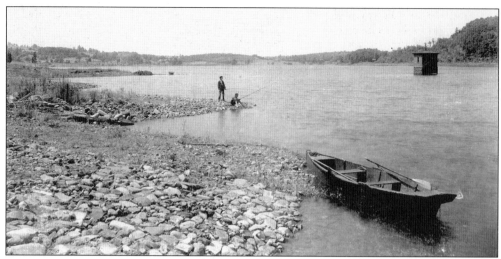

FISHING AT SHUTTLE MEADOW, C. 1880. Years before it became part of the New Britain water supply, Shuttle Meadow Lake, located in the northeastern corner of Southington, was used as a summer resort. The Dunham family established the Lake House on the eastern shore and provided lodging, dining facilities, band concerts, boating, and fishing. In 1885, New Britain enacted an ordinance prohibiting all recreational use of the reservoir for fear of pollution. The issue was litigated by the Dunhams for several years, but in 1894, all activity ceased and the Lake House was torn down.

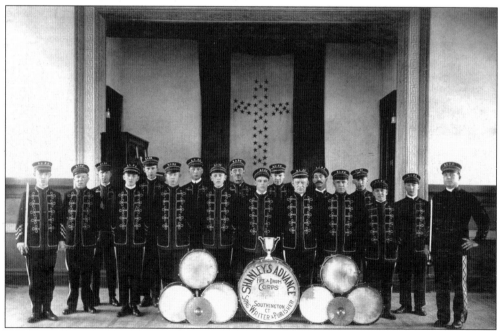

SHANLEY'S ADVANCE FIFE AND DRUM CORPS, MARCH 19, 1921. Benjamin Shanley was a songwriter who as a student at Holy Cross wrote the "Chu Chu" song. In June 1920, he organized the fife and drum pictured here. They were photographed at the town hall practicing for an Easter concert. Members included James Carrington, Thomas Donahue, J. Kennedy, Raymond Keating, Maj. H. Wrinn, Martin Kavanaugh, E. G. Philibrick, J. Barber, T. Skinner, J. Skinner, A. England, T. England, A. Moran, A. Delaney, E. Boyle, and H. Lacey.

ROARING BROOK. Oliver Dwight Woodruff, or "O. D." as he was known, sits amid the falls with fellow hikers. The falls and the Great Unconformity, a rare geological formation, were popular Victorian destinations and located on the western side of town.

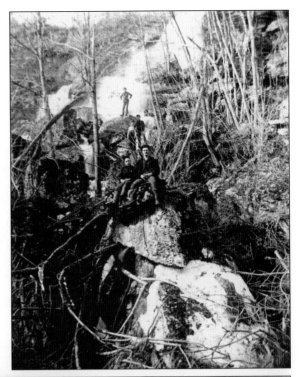

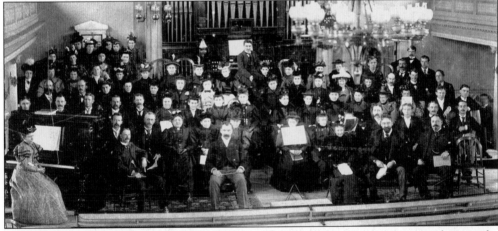

SOUTHINGTON HARMONIC SOCIETY, APRIL 16, 1895. This photograph was taken in the Southington First Congregational Church prior to the society's performance of "The Creation." The pianist is Mrs. Edwin Walkley, and the director, Richmond Paine, sits with his baton in the front row. The Southington Harmonic Society was organized in the fall of 1879 and performed its first concert on December 2, 1879. In the years before movies and television, the Southington Harmonic Society and many other clubs provided opportunities for socialization and entertainment at night to the townspeople, many of whom had worked all day. The list of participants in these concerts reads like a who's who of the town. Russell Gad Andrews, Lindsey Hutton, Lena Knapp, Leila Barnes, Marcus Holcomb, Lena Camp, and Una McKenzie were just a few of the members. The society performed not only in the Southington First Congregational Church, but also in the Foot Guard Hall in Hartford, the Plantsville Congregational Church, and the Kensington Congregational Church before disbanding in 1904.

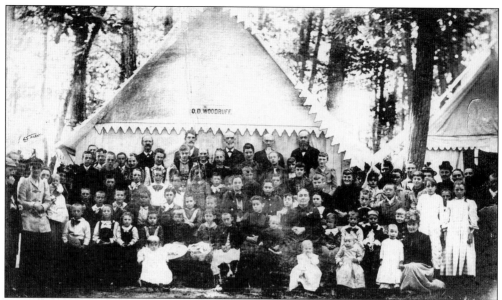

ADVENT CHRISTIAN CAMPGROUND. Oliver Dwight (O. D.) Woodruff (1833–1914) stands among his fellow Adventists at the Advent Christian Campground at Dunham's Grove on Queen Street. Organized in 1870, the camp started with a few tents and an outdoor amphitheater, but soon families were building small cottages that surrounded a large meetinghouse and dining hall. At the height of its popularity, over 1,000 people came to hear the evangelists preach. When the temperance movement swept the country, O. D. and his wife, Emogene, became strong advocates of abstinence. Emogene was president of the Women's Christian Temperance Union in town and regularly visited the saloons to preach and pass out literature on the evils of alcohol.

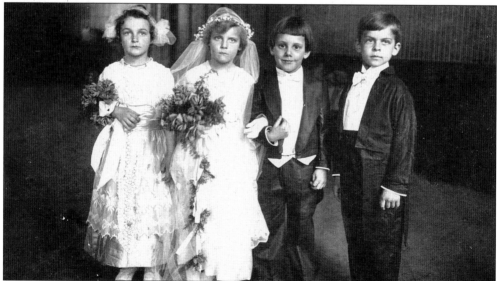

TOM THUMB WEDDING, APRIL 4, 1918. The Harmony Chapter of the Order of Eastern Star presented the "Tom Thumb wedding" at the town hall to benefit the Red Cross. Pictured from left to right are Marjorie Judd, Theda Dickerman, Albert Ralston, and Kenneth Williams. Ralston would become president of the Beaton and Corbin Company and Williams the vice president of the Southington Bank and Trust Company.

LAKE COMPOUNCE, c. 1910. Every Sunday Marshall P. Norton and Isaac Pierce engaged special acts to entertain the crowds that flocked to the amusement park. This photograph taken from an early glass slide shows platform divers thrilling the crowd.

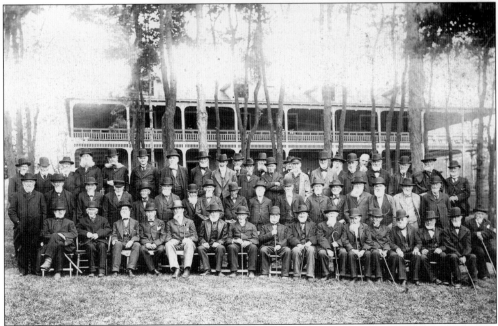

OLD MEN'S ASSOCIATION, SEPTEMBER 1896. This was the first annual meeting of the Old Men's Association organized by Pierce and Norton, owners of Lake Compounce. Members were required to be residents of Southington, Bristol, or Plainville and have attained the age of 75 years. The men enjoyed a sheep barbecue in the casino, followed by entertainment.

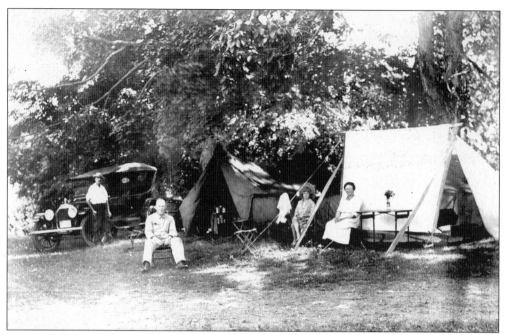

SUMMER FUN, C. 1928. Every summer the Smileys would visit and camp on the ledge in the pasture in back of the Moore home at 469 Andrews Street. From left to right are David Ackart, Walter Smiley, Susan Moore, and Grace Smiley. Ackart, a photographer, was Moore's grandfather.

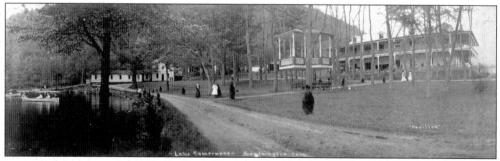

LAKE COMPOUNCE, C. 1896. An early view of the lake shows the newly built casino where people could dine on the first floor and enjoy entertainment on the second floor. The bandstand sits near the edge of the lake. In the distance, for revelers' further enjoyment are the bowling alley, the pool hall, and a place to have a tintype taken to remember the day.

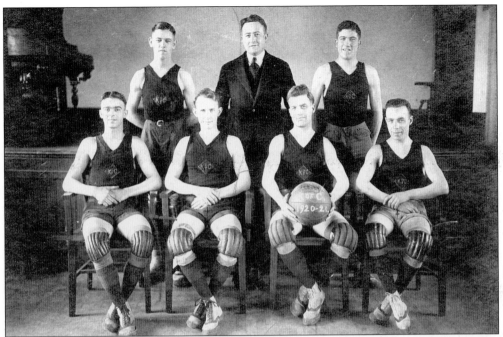

K OF C BASKETBALL, 1920–1921. Pictured are members of the Southington team in the State Kacey Basketball League. Although the team did not win the championship that year, Paul Hartford was the league's leading scorer. They are, from left to right, (first row) Hartford, ? Kavanaugh, ? Gill, and ? Drury; (second row) ? Coyle, ? Erbe (manager), and ? Keating.

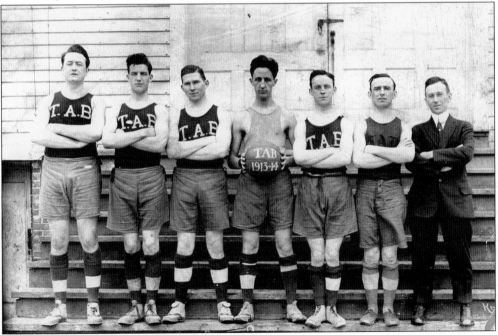

ST. THOMAS'S TOTAL ABSTINENCE BENEVOLENT SOCIETY BASKETBALL TEAM, 1914. Pictured from left to right are J. Erbe, ? Gill, F. Kane, captain L. Degnan, E. Kane, G. Kane, and manager Peter Kennedy.

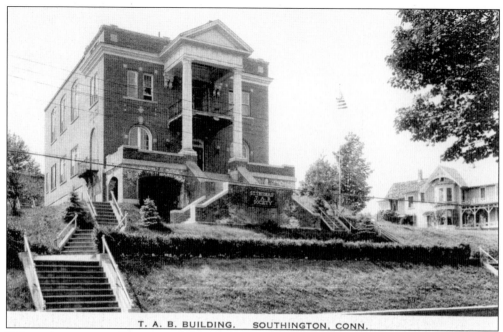

T. A. B. BUILDING. SOUTHINGTON, CONN.

TOTAL ABSTINENCE BENEVOLENT SOCIETY HALL, C. 1915. St. Thomas's Total Abstinence Benevolent Society (TABS) was founded in 1908. For many years it held its meetings and social events over the Neal and Guernsey Store on the west side of the green. Finally, in 1915, TABS built the large hall featured in this picture located on the present site of the Derynoski Elementary School. The society flourished for a number of years but found it hard to make its mortgage payments during the Depression. Finally the hall was sold in 1944 to the town as the site of a new high school.

THE PANOMA GRANGE AND THE UNION GRANGE, APRIL 16, 1908. Members from both the County Grange organization and the Union Grange of Southington met for lunch and entertainment and to discuss the important agricultural issues of the day. The Union Grange was founded in 1885.

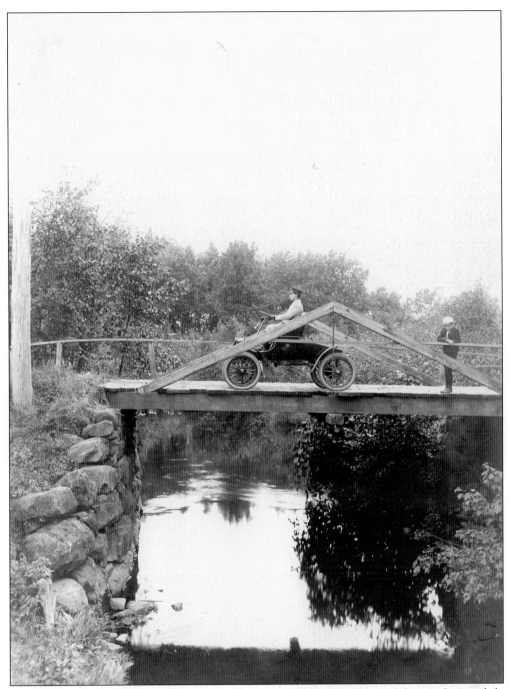

SUMMER DRIVE, C. 1903. Bradley Barnes crosses the Quinnipiac River at Curtiss Street while Robert O'Connell looks on. Barnes wrote Ford and complained that the car did not have enough power. After the purchase of another Ford, Bradley bought the Pope Hartford in search of a faster ride.

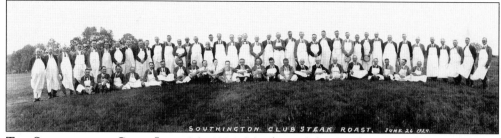

THE SOUTHINGTON CLUB, JUNE 26, 1924. Members of the Southington Club are about to enjoy a steak barbecue. The club was founded in 1916 and provided assistance to Southington residents in need. Bradley Barnes, Samuel Bowers, Frank Barnes, and Edwin Lotz were all members at one time.

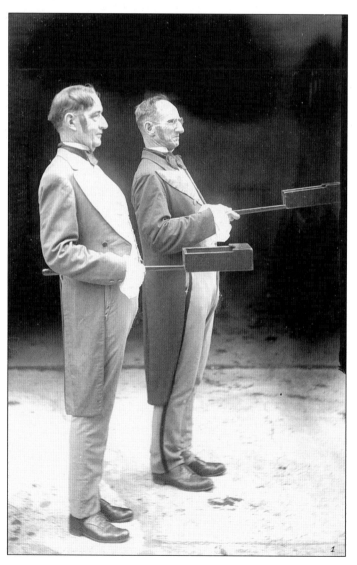

COLONIAL CELEBRATION. In 1924, the First Congregational Church celebrated its 200th anniversary with a Colonial pageant. Pictured here in costume are two of Southington's most successful businessmen, Frank Barnes and Frank Wells. Barnes (1866–1940) was president of the Southington Lumber and Feed Company on Bristol Street. Wells (1858–1930) was the president of the Beaton and Corbin Manufacturing Firm on North Main Street.

THE LAKE HOUSE. Before the Civil War, the Dunham family decided to take advantage of the natural beauty of the water at Shuttle Meadow and build a summer resort right on the eastern shore of the lake. They opened a dining room, a bandstand, a bowling alley, docks, and a hostelry, and the public flocked to the site. However, when the City of New Britain decided to convert Shuttle Meadow into a reservoir there were worries that the Lake House might be polluting the water supply. As years passed, concerns increased until the city forced the closure of the resort in 1885. Although the Dunham family took the city to court over the issue, the city lost and the Lake House vanished without a trace.

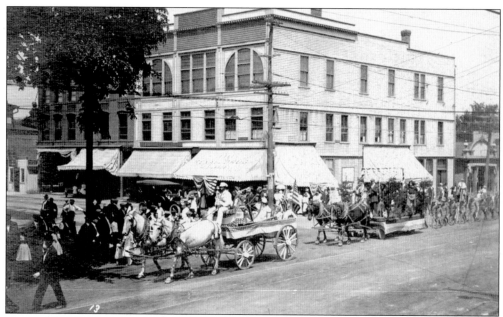

PARADE THROUGH TOWN. Pictured is an early Fourth of July celebration through town. Following the lead wagon is a float filled with members of the International Order of Red Men, Wonx Tribe, founded in 1893. The Boy Scouts are also on the march.

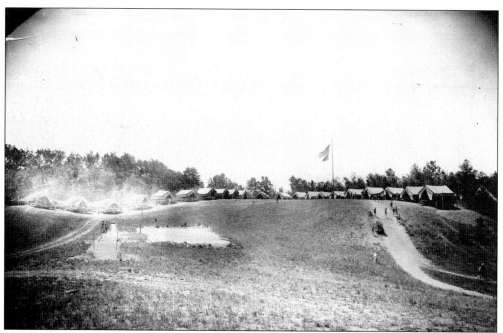

SPRING LAKE, C. 1922. L. V. Walkley purchased Spring Lake on December 27, 1895. He built a small cottage on the lake and crisscrossed the land with bicycle paths and footpaths. In the summer he entertained his guests here, and in the winter he harvested the ice. On August 13, 1922, Vernon C. Bates and other members of the New Haven Boy Scout organization bought the property and opened Camp Sequassen.

50

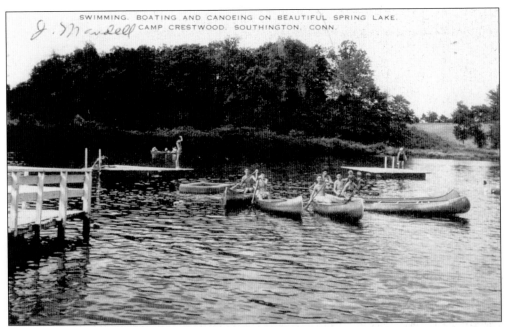

CAMP CRESTWOOD. Pictured are the girls of Camp Crestwood canoeing on Spring Lake. Camp Crestwood was the successor to Camp Creyloe, also a girls' camp.

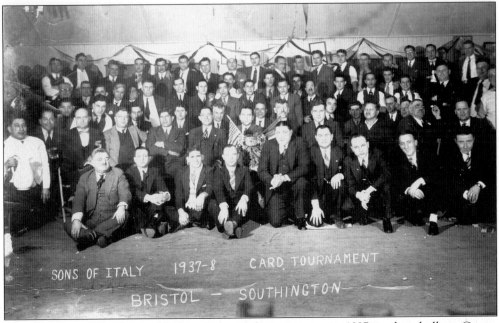

SONS OF ITALY 1937-8 CARD TOURNAMENT
BRISTOL — SOUTHINGTON

SONS OF ITALY. The Sons of Italy enjoy a card tournament in 1937 in their hall on Center Street. Nick Romano, Jiggy Egidio, and Larry DiAngelo are in the front row.

THEATRICS, C. 1899. This early play was performed under the direction of the Reverend Ferdinand Blanchard of the First Congregational Church. Pictured from left to right, they are (first row) Blanchard, ? Neal, and Raymond Lewis; (second row) Allen Upson, Charles Neal, unidentified, unidentified, Charles Langdon, Austin Chafee, and Raymond Walkley.

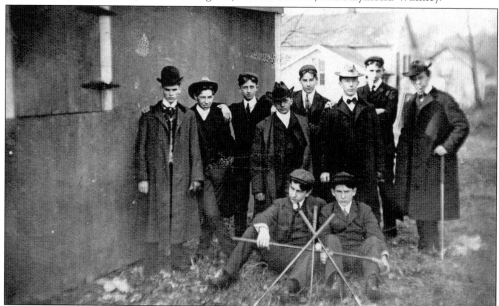

GOLF BEFORE A COURSE, C. 1900. Bradley Barnes and his friends assemble to play a round of golf. Since there was no golf course in Southington at the time, they were probably improvising in a local pasture. Pictured from left to right, they are (first row) George Lewis and William Warden; (second row) Bradley Barnes, Adam Orr, Robert Jones, Clarence Langdon, Floyd Neal, John Madsen, Harlow Jones, and Jay McCleary.

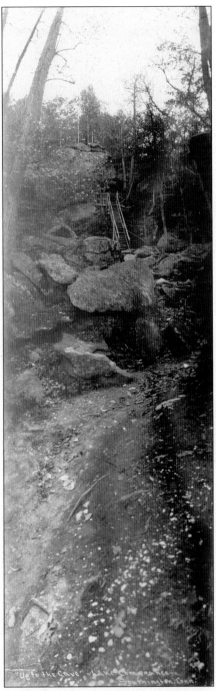

SIMPLE PLEASURES, 1909. Before the trains, cars, and airplanes came to Lake Compounce, the Victorians enjoyed simpler entertainment. This photograph taken by Emerson W. Hazard shows the stairway to the cave where it was advertised that Native Americans once lived. Other stairs to White Rock promised spectacular views of the Farmington Valley. For the factory workers with only one day of leisure a week, this quiet place beside a crystal clear lake must have seemed like paradise.

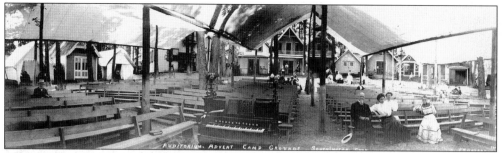

ADVENT CAMPGROUNDS, 1907. By the time this picture was taken at the campgrounds, most of the original tents had been replaced by small cottages facing the large open-air auditorium where church services were held. Most of the cottages still stand today, hidden from view on the upper portion of Queen Street.

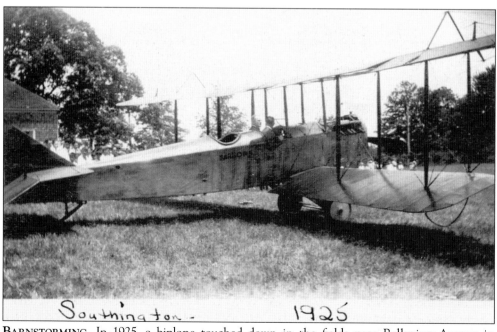

BARNSTORMING. In 1925, a biplane touched down in the fields near Belleview Avenue in Southington and offered anyone with courage and $2 a chance to fly in the airplane. As pictured, many turned out for the event.

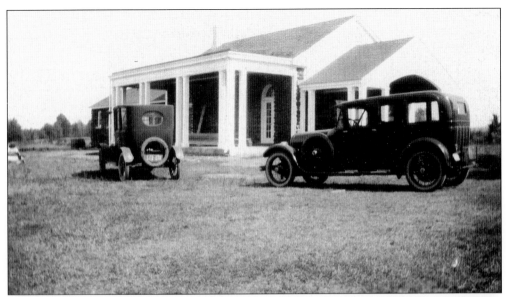

SOUTHINGTON COUNTRY CLUB. In the summer of 1922, the Parsons Golf Corporation was formed to try to establish a golf course in town. That summer the corporation was able to lease 90 acres of land known as the Webster Farm in the South End District. The Southington Country Club was formed at this time with Oscar Knapp as president, Frank Taylor as vice president, Robert Simpson as secretary, and Henry B. Armstrong as treasurer. The first golf tournament was played on temporary greens on Labor Day 1922. That fall A. A. Boyce, a local builder, began construction of the clubhouse pictured here.

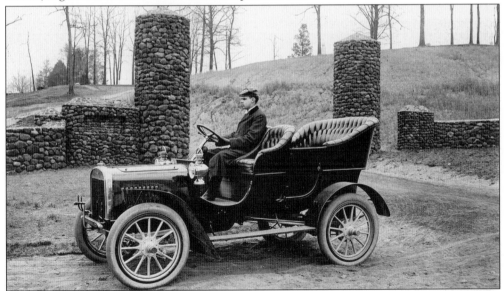

BRADLEY BARNES, C. 1905. Bradley Barnes poses outside the entrance of Oak Hill Cemetery in his 1905 Model B Ford. In 1908, he traded both his Model B and his 1903 Model A Ford for a new Pope Model M manufactured in Hartford. A few years later, he bought another Pope, a Model 28 now on permanent exhibit at the AAA headquarters in West Hartford. Barnes was a lifelong automobile enthusiast owning a Scripps Booth, a Franklin, and a Marmon before returning to the more conventional Buicks and Fords.

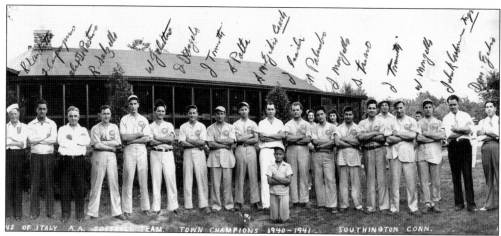

SONS OF ITALY BASEBALL TEAM, 1940–1941. The Sons of Italy always supported sports teams. Pictured on this championship team are, from left to right, R. Lamditta, F. Campagano, A. DePastino, R. Salzello, unidentified, W. Galiette, J. DeAngelo, J. Tonnotti, A. Polta, A. M. Egidio (coach), J. Nardi, A. Polumbo, J. Mongillo, D. Triano, unidentified, J. Tonnotti, W. Mongillo, J. Carbone (manager), and Dom Egidio.

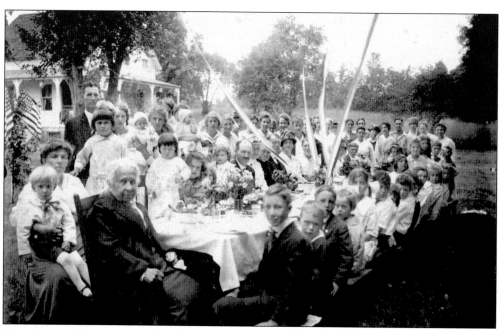

EAST STREET PICNIC, 1919. Neighbors from the area surrounding East Street gathered every summer for a picnic. This year it was held at the Root home at the junction of East Street and Kensington Road.

Three

HOMES AND CULTIVATIONS

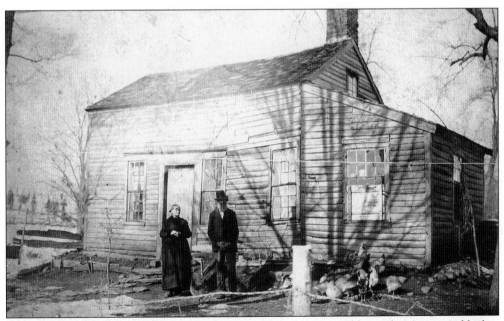

RUEL FOWLER HOME, 1885. Joseph Thompson, a woodcutter, and his wife, Mary, stand before an 18th-century dwelling once located on the north side of Kensington Road on a knoll above the small pond. The home, built by Martin Fowler, an African American, was owned at the time of the photograph by his son Ruel Fowler (1818–1894), who lived here on and off with his wife, Densey, and mother, Kate, until his own death on July 12, 1894. The house disappeared in the early years of the 20th century.

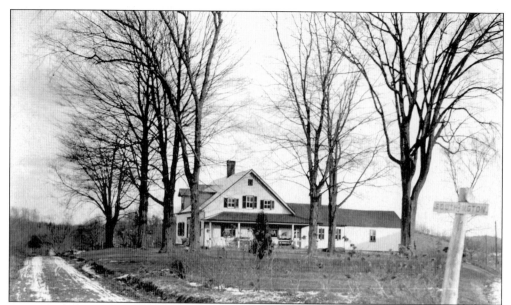

WOODRUFF HOME, C. 1900. Located on the corner of East Street and Kensington Road, this house was built during the latter part of the 18th century by Isaac Woodruff (1737–1818), a direct descendant of Southington's first settler, Samuel Woodruff. His son Isaac (1773–1807) and his grandson Urban (1799–1873), first president of the Southington Savings Bank, occupied the house before it passed out of the Woodruff family. John Jamieson owned the house in 1901. He harvested ice each winter from nearby Sloper's Pond and delivered it to many Southington residents. At some point in time, the dormers and side porch were removed to restore the home to its Colonial appearance. The Holmquists owned and preserved the house for the better part of the 20th century.

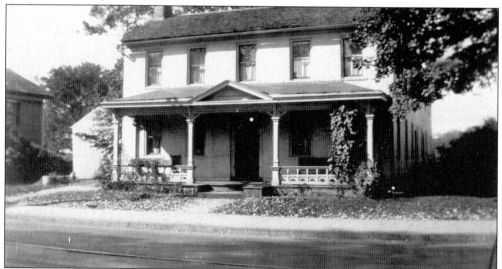

SAMUEL ANDREWS SR. AND JESSE OLNEY HOUSE, C. 1920. Located at 116–119 North Main Street, this house had two famous owners. Samuel Andrews Sr. was a Revolutionary soldier, and Jesse Olney (1789–1872) was the famous author of a geography and atlas that was outsold only by Noah Webster's speller. The building still stands without the porch and is the only example in Southington of a brick Federal-style home.

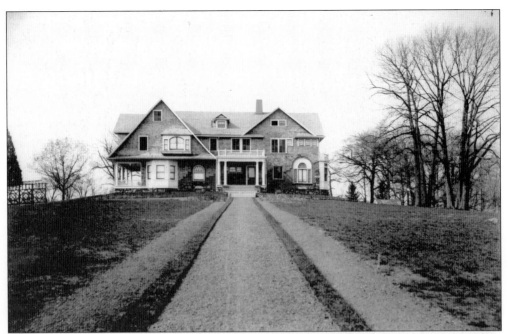

WALKLEY MANSION, C. 1900. Known as "the Knoll," this home was built for L. V. Walkley and his wife, Ellen, in 1899 and was the site of a lavish open house for 100 on February 18, 1900. Walkley owned the Pultz and Walkley Bag Company in Plantsville and sold it to a competitor for $1.2 million. He later successfully ran the H. D. Smith Company.

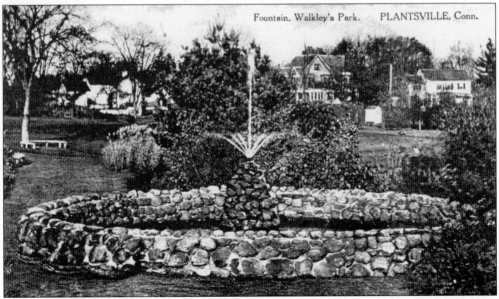

WALKLEY PARK, C. 1910. Developed by Walkley on the land that was encompassed by Cowles Avenue to the south, Elm Street to the west, Prospect Street to the north, and Summer Street to the east, the park was equipped with a pond, pathways, manicured lawns, and a fountain. Walkley offered the park to the town, but the town refused the open space. Eventually the land was covered with homes, but the fountain remains in the backyard of a home on 35 Elm Street, a reminder of Southington's loss.

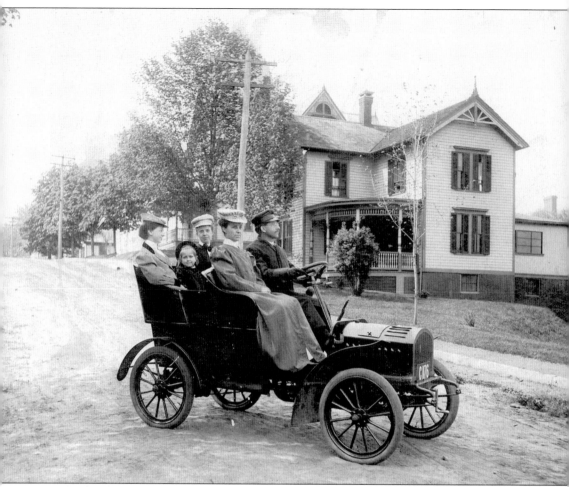

ORR FAMILY, C. 1906. George Orr and his wife, the former Maud Allen, and (from left to right in the backseat) Minnie Orr Judd, Helen Orr, and Kate Orr are pictured in front of their house at 107 Oak Street in their Cameron automobile made in Pawtucket, Rhode Island. George was the owner of the Orr and Judd Shoe Store located on Center Street for many years.

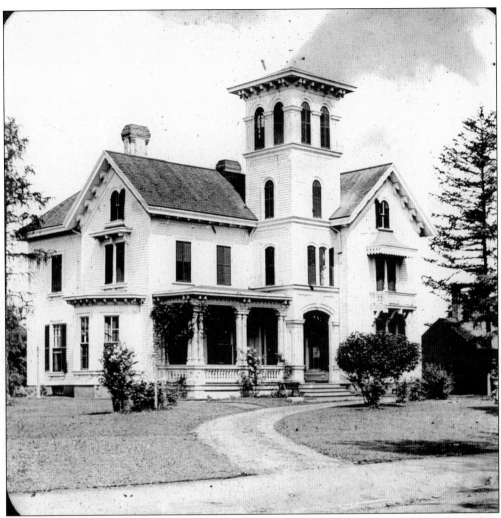

THE NEAL HOUSE, C. 1900. Roswell A. Neal (1821–1891) was one of the leading industrialists in Southington. He was at one time president of Peck, Stow and Wilcox, Southington Cutlery, Aetna Match Company, and the Southington Water Company. He built the house at 130 Main Street in 1861 for his wife, Eunice, and his five children. In 1905, the home was purchased by Willard J. Gould and used for his funeral business. Today, although the tower and much of the decorative trim are gone, the building still stands and is currently used as a bank.

TWICHELL HOUSE, C. 1910. This home was built on West Street in 1869 in the elaborate Second Empire style for Edward W. Twichell (1839–1919) and his wife, the former Sarah Frisbie. Twichell was the treasurer of H. D. Smith and Company in Plantsville. In later years, the home was occupied by Julian Florian. It still stands with most of its rich details intact.

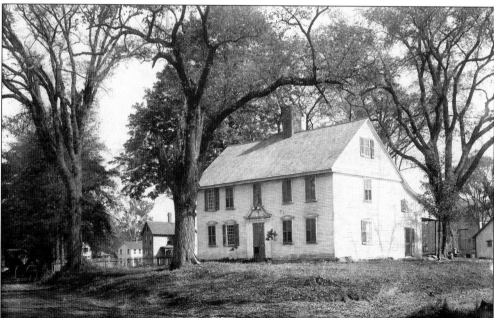

THE REVEREND WILLIAM ROBINSON HOUSE, C. 1880. Located on the corner of Darling Street and North Main Street, this home was built by the Reverend William Robinson (1754–1825) in August 1782. The reverend was the minister of the First Congregational Church for 41 years. The house burned in the 1950s.

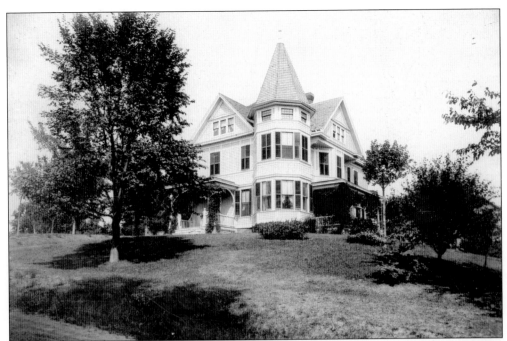

CHARLES PERSIANI HOME. This Queen Anne–style home was built on Cowles Avenue for Charles C. Persiani and his wife, the former Emma Erbe. Persiani was the superintendent of Clark Brothers' Bolt Company, president of the Plantsville National Bank, a member of the school board, an inspector with the Southington Water Company, and a representative in the Connecticut legislature.

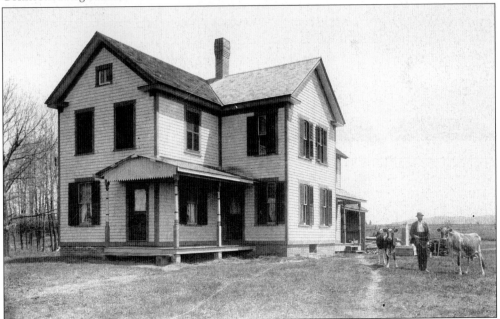

WINCHELL HOUSE, PLANTSVILLE, 1902. Elmer Winchell stands outside his home on South Main Street just north of Mulberry Street. Winchell was a farmer and also worked for Clark Brothers' Bolt Company. The area is now highly developed, and this house is no longer standing.

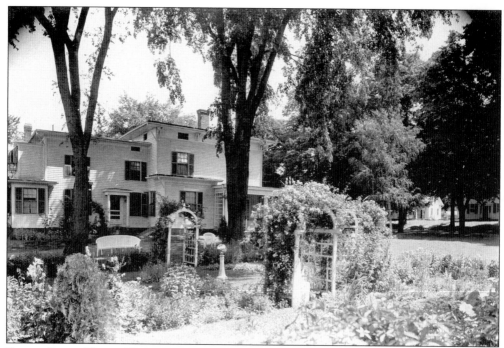

ETHEL OXLEY HOME, NORTH MAIN STREET, C. 1935. Pictured are the house and gardens of Ethel Oxley (1882–1968), widow of Alfred Oxley, the owner of the Oxley Drug Store. Ethel's gardens rivaled those of Bradley Barnes, her nearby neighbor.

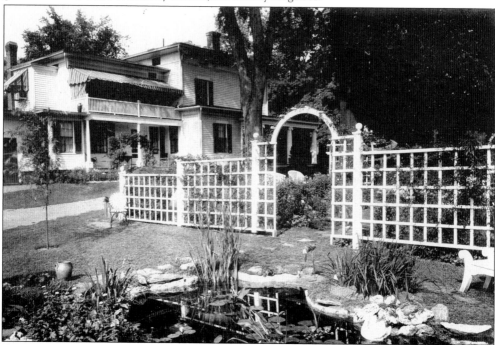

ETHEL OXLEY FISHPOND, C. 1925. Ethel Oxley had Samuel McKenzie, the superintendent of the Southington Water Company and a civil engineer, design this fishpond. Long after the home was demolished, the fishpond remained, a reminder of the former grandeur of the site.

The Truman Barnes House. This Victorian home of Truman Barnes (1835–1912) was located on the corner of Main Street and what is today Columbus Avenue. The Neal house to the rear of this building is now gone.

Dr. Henry Skilton Home, South Main Street, Plantsville. Pictured is the 1947 restoration of the Skilton house by the Bardes family. Dr. Henry Skilton (1748–1802) was a self-taught physician and a large landowner in Southington. In the 20th century, the Skilton family held reunions and issued commemorative Wedgwood china featuring this house that has become highly collectible.

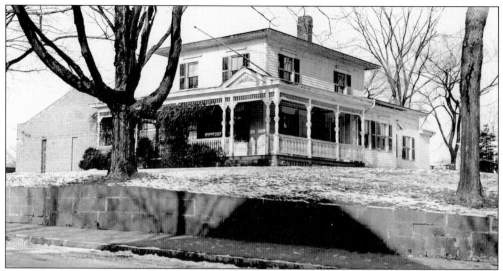

MERIT WOODRUFF HOUSE, HIGH STREET. Situated at 6 High Street, this was the home of the successful businessman Merit Woodruff. It was torn down in the 20th century to make room for the expansion of the YMCA.

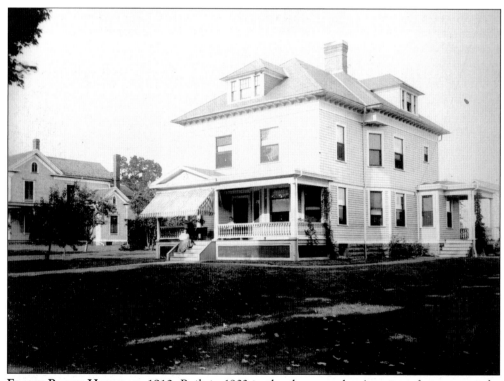

FRANK PRATT HOUSE, C. 1910. Built in 1903 in the then-popular American foursquare style, this home is located on Meriden Avenue. Frank Pratt's daughter Julia married Edward Russell here in 1910.

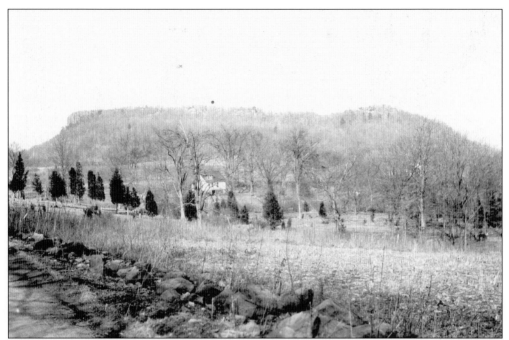

MAY KELLOGG HOUSE, C. 1915. May Kellogg was a schoolteacher for many years in Southington and several other communities. When her stepfather, Charles Moore, died in 1913, her mother, Estelle, came to live with her in a house built for them on the Moore land on Carey Street. Kellogg's house, with High Rock and Jackass Peak in the distance, depicts a very rural and deforested Southington as it was in the early 20th century.

IRA UPSON HOUSE, MAY 30, 1814. This late-18th-century dwelling located on West Street was owned by Ira Upson and his wife, the former Lucy Woodruff.

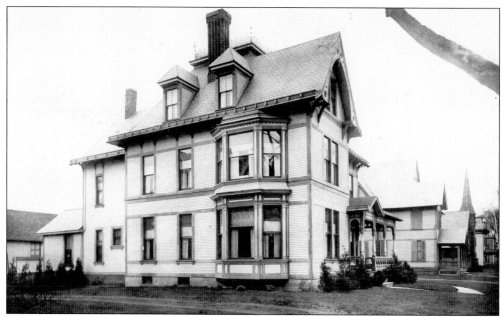

MANSIONS ON MAIN STREET. Pictured are the stately Queen Anne–style homes that once lined the east side of Main Street from the Methodist church to the corner of Vermont Avenue. The home just before St. Paul's Church was owned by Howard Williams, who was the paymaster for the Southington Hardware Company. In 1920, Williams sold his home to St. Paul's Church and it was used as a rectory for several years before it was demolished for a parking lot. The house in the foreground belonged to Marcellus Wilcox. Fully restored, it is currently used as a law office, and it remains the sole survivor in this row of homes.

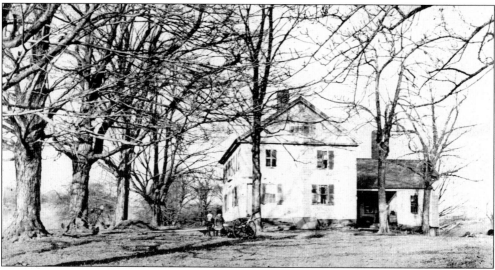

CHARLES MARTIN MOORE HOME, FORMERLY THE LUMAN ANDREWS HOMESTEAD, C. 1914. Charlotte and Adelaide Moore pose in the side yard. In 1828, blue limestone was discovered in the backyard sparking one of the first Portland Cement Industries in the United States. The business was highly profitable, and the Andrews, Moore, and Barnes families built kilns and mills to process the cement and continued the business until the blue limestone was depleted in the 1850s.

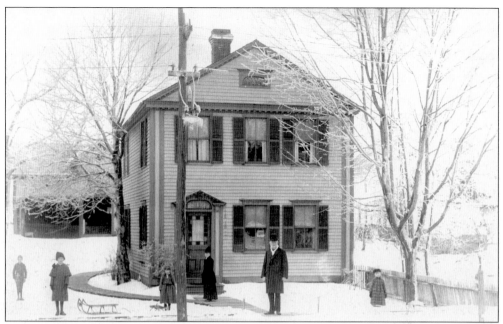

BARNES HOME. This house, located on the west side of the green, was once owned by Norman Barnes and his wife, the former Sylvia Bradley. Sylvia's father, Amon Bradley, was a prosperous businessman and landowner in town. Bradley Barnes was born and raised in this house. Like most of the other buildings on the west side of the green, it was demolished after Bradley Barnes's death in 1973.

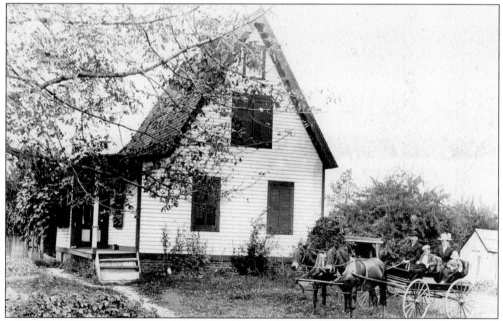

GLASNAPP HOME, C. 1909. At one time, the Charles Glasnapp home was located on Queen Street opposite Lazy Lane. Charles is pictured here in the front of the carriage with his son Albert. His wife is sitting with their daughter Cora, who later in life would become the assistant town clerk of Southington.

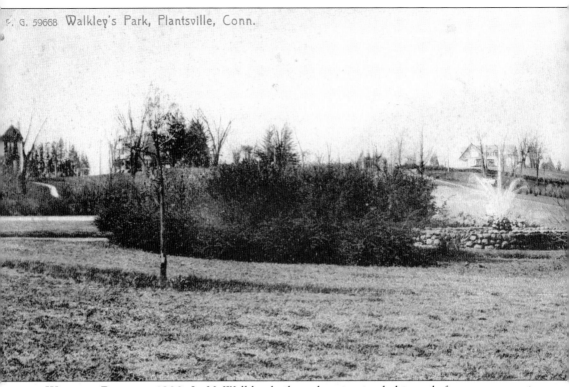

WALKLEY PARK, C. 1900. L. V. Walkley built and maintained this park for many years in Plantsville. It was bordered by Cowles Avenue, Elm Street, Prospect Avenue, and Summer Street. The Walkley mansion can be seen in the center of the picture on the hill overlooking

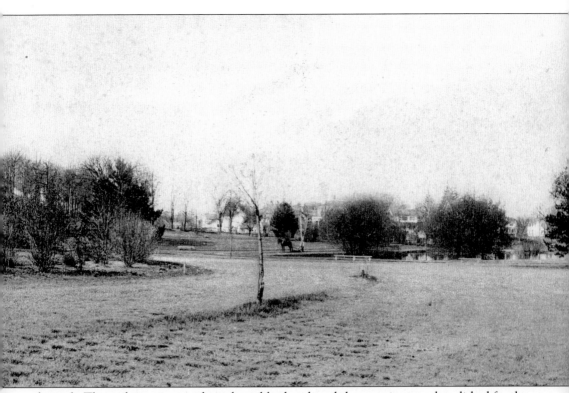

the park. The park is now a residential neighborhood, and the mansion was demolished for the construction of a nursing home.

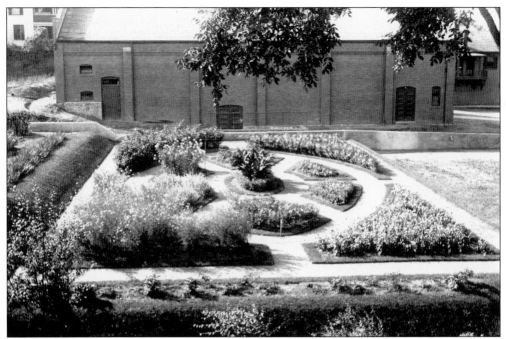

BARNES'S GARDENS, MAIN STREET. Bradley Barnes and his wife, Leila, maintained tiered gardens on the south side of their property. In the early years, Frank Fiorendella assisted them, and later Peter Santago and his son Peter meticulously kept the gardens in shape. The Coleman Theater is pictured in the background before it was enlarged.

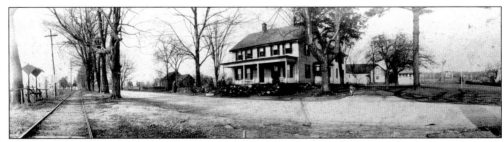

CHARLES CLARK HOME, 1915. Located on Clark Street, this home was built in 1810 by the Clark family. It was the home of Charles H. Clark, president of Clark Brothers' Bolt Company and a popular and prosperous businessman in town.

Four

BUSINESS AND INDUSTRY

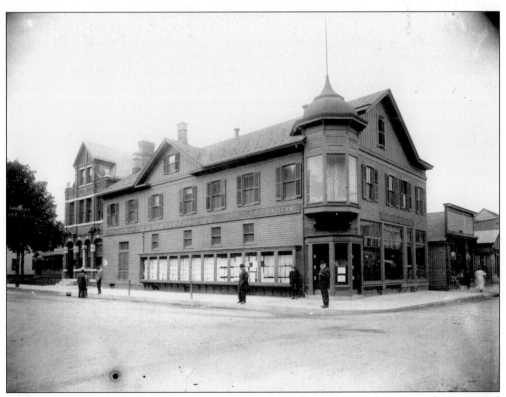

THE C. H. BISSELL DRY GOODS STORE. Once located on the south corner of Center and Main Streets, this dry goods store was founded by Charles Bissell in 1886 and was operated by him until his death in 1925. The building burned in 1943. Bissell, an amateur botanist, was president of the Connecticut Botanical Society and wrote *Flora of Connecticut* and collaborated on *Flora and Fauna of Southington* with his neighbor and fellow enthusiast on North Main Street, Luman Andrews.

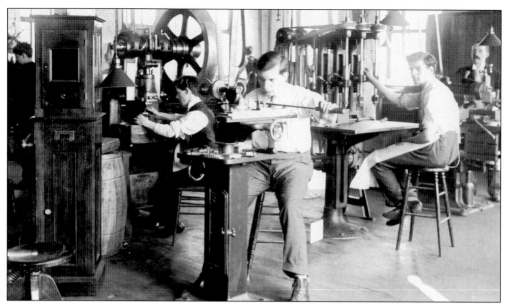

THE PHOTO MACHINERY COMPANY, SOUTHINGTON. In 1903, Julian Florian, an industrial chemist, developed an emulsion formula that allowed for instant photographs without the necessity of a negative or glass plate. In 1907, Florian manufactured the first photograph machine that delivered instant photographs to delighted recipients at Lake Compounce, Coney Island, Luna Park, and other amusement centers and public gatherings. In 1928, the rights to the emulsion formula were sold to Eastman Kodak, but the Photo Machinery Company continued to manufacture the machines well into the 1940s.

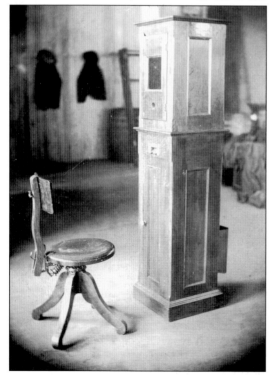

AUTOMATIC PHOTOGRAPH MACHINE. Pictured is Julian Florian's original photograph machine that provided instant photographs.

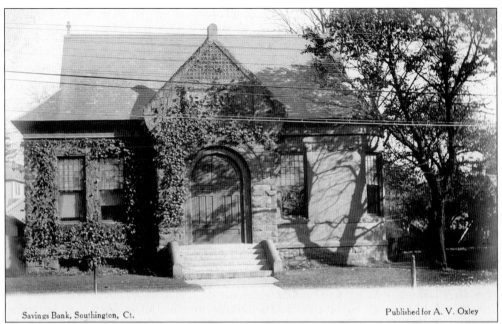

SOUTHINGTON SAVINGS BANK, C. 1900. Chartered in May 1860, the Southington Savings Bank operated in several private homes and on the second floor of the Southington National Bank before building this brownstone edifice on Main Street in 1886. The bank's first president was Urban Woodruff and its treasurer Henry R. Bradley. Nancy Langdon became the first depositor on July 4, 1860. This building remained the bank's home until it was demolished and replaced by a modern structure in 1955. After 142 years in business, the Southington Savings Bank was sold to Banknorth in 2002.

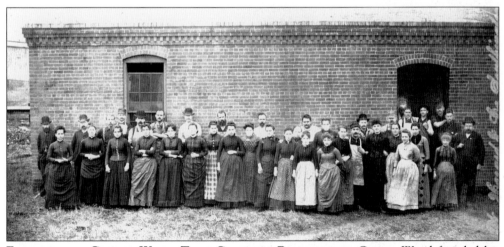

EMPLOYEES OF GEORGE WOOD TOOL COMPANY, PLANTSVILLE. George Wood founded his company in 1905 on Summer Street. He manufactured a screwdriver that he sold to Stanley Rule and Level Company of New Britain. Eventually Stanley bought the business.

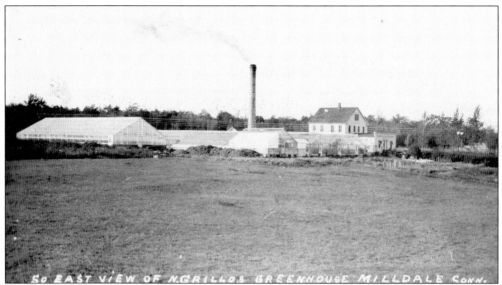

N. Grillo Florist, Milldale. Nicholas Grillo (1888–1975) was born in Tusa, Italy, and immigrated to the United States in 1906. After apprenticing with the noted florist A. N. Pierson in Cromwell, Grillo opened his own greenhouses in 1915. His specialty was roses. In 1930, he developed the thornless rose, and over the years, he gained a national reputation with many gold and silver medals at the New York and Philadelphia flower shows. Eleanor Roosevelt ordered roses from Grillo.

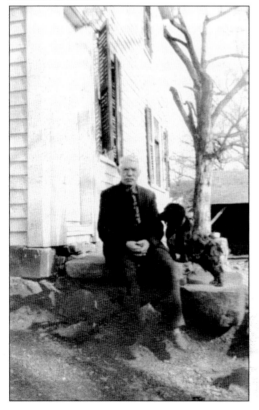

The Iceman, c. 1918. John Jamieson was born in Lanarkshire, Scotland, in 1857 and immigrated to the United States in 1875. He eventually settled in the former Woodruff home on the corner of East Street and Kensington Road. In 1905, he bought the ice business from George Orr. For the next 30 years, he and his brother Thomas harvested the ice from Sloper's Pond and delivered it to Southington residents. He married Minnie Moore and built an apartment on the back of the Moore residence at 469 Andrews Street. He died at the age of 90 in 1948.

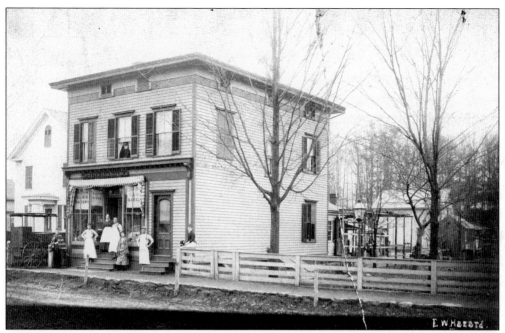

FAITH BAKERY, C. 1890. Joseph Faith (1822–1891) is pictured with his wife, Elizabeth, and five of his seven children in front of his bakery at 205 Bristol Street. Faith emigrated from Germany and became a successful businessman in town. After his sudden death in 1891, his sons Edward and Charles operated the store until 1914.

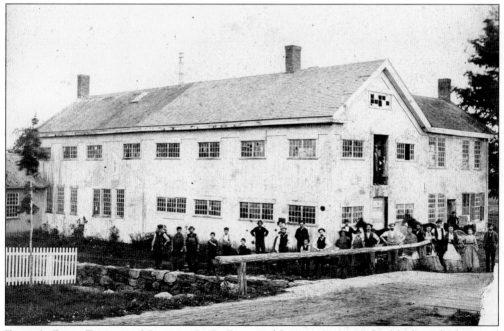

FROST'S BOLT FACTORY, MARION. L. B. Frost and his son Ira owned a blacksmith shop and farming supply business in Marion. In 1842, they began manufacturing bolts here in this factory. The Frost family continued to manufacture their product until the death of Levi D. Frost in 1900.

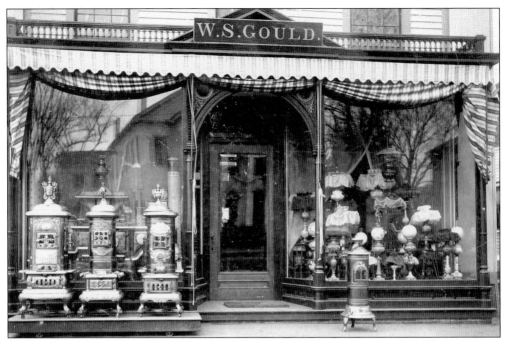

THE GOULD COMPANY. After many years in the retail business in Hartford, Winfield Scott Gould (1847–1923) came to Southington and purchased a store in Plantsville once owned by J. A. Kenyon. His son Willard Gould joined him in the business in 1893. Within a few years, they found the quarters in Plantsville too small and they moved to a building on the west side of the green. As pictured, the Goulds sold furniture, china, crockery, and other household furnishings. In addition, they also ran a plumbing, heating, and funeral business on the side.

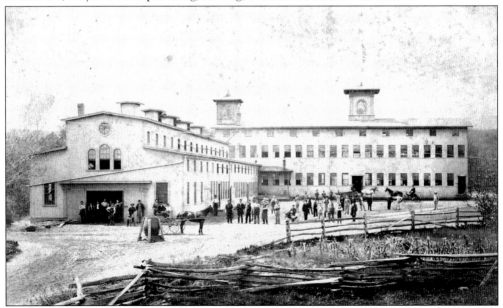

H. D. SMITH, PLANTSVILLE. The H. D. Smith Company, manufacturer of forgings and tools, was organized in 1850 by H. D. Smith, G. F. Smith, E. W. Twichell, W. S. Ward, and E. P. Hotchkiss. Pictured here in 1870, it was one of the factories powered by the Eight Mile River.

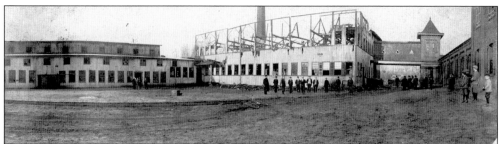

H. D. SMITH FIRE, NOVEMBER 1, 1910. Fire broke out in the night at the wooden factory building of H. D. Smith, causing a total loss. L. V. Walkley, president of the company, did not even wait for the insurance adjuster, but had the company set up immediately in the vacant bag shop down the road. So successful was Walkley in maintaining production that the company voted its usual dividends at the annual meeting in March 1911.

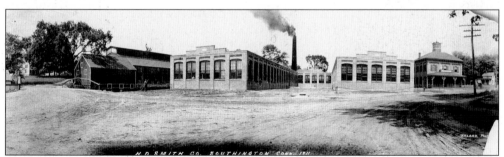

THE NEW H. D. SMITH COMPANY, 1911. The new building was designed by Charles H. Palmer of Meriden and was built of steel and brick to resist fire. It opened in 1911.

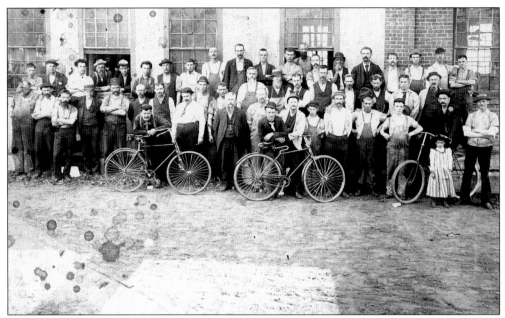

H. D. Smith Company, c. 1890. Pictured here are the employees of the H. D. Smith Company posing in front of the shop in Plantsville.

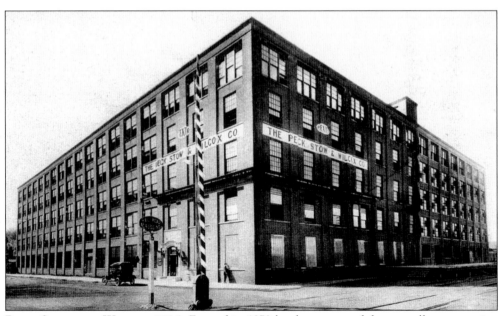

Peck, Stow and Wilcox, 1926. Formed in 1879 by the merger of three smaller companies, Peck, Smith and Company; S. Stow Manufacturing; and Roys and Wilcox of Berlin, this manufacturer grew to be the largest employer in Southington.

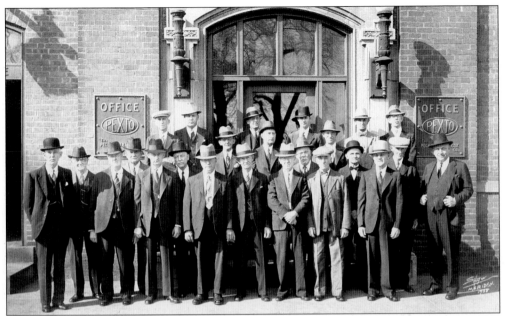

PEXTO, APRIL 28, 1938. The men who had worked for Pexto for 40 years or more assemble before leaving for the Hartford Club where they were honored with dinner and entertainment by the Hartford County Manufacturers Association. From left to right are (first row) Peter Hutton, Edward Brown, Harry Willis, William Kline, Daniel O'Brien, Michael Toomey, Peter Mongillo, James Scott, John Connors, Charles Trostel, George Aspinall, Louis Wolfe, Thomas Egan, Thomas Flynn, and Mark Lacey; (second row) Frank Booth, Fred Ely, and George Hubbard; (third row) Frank McHugh, Edward Hackbarth, A. J. Tarpp, Samuel Wilcox, William Wendel, and Daniel O'Keefe.

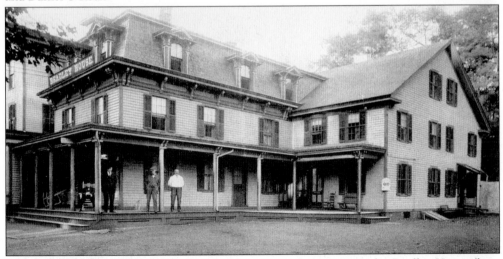

BRADLEY HOUSE, C. 1900. When it closed on December 28, 1919, the Bradley House (later known as the Southington Inn) was one of the oldest hotels in Connecticut. Owned by Amon Bradley, the hostelry, bar, and dining room was run by a long list of proprietors. George M. Cohen and John L. Sullivan, the heavyweight champion of the world, once stayed here. Like many other hotels and restaurants that relied on the sale of alcohol, the Bradley House became a victim of the 18th Amendment. It was later razed to make room for the new town hall.

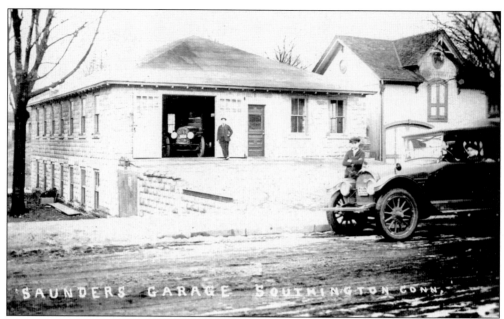

GEORGE SAUNDERS'S GARAGE. As early as 1901, George Saunders owned a carriage maker's shop on Liberty Street. When automobiles became popular, he converted his carriage shop into a garage and opened another garage behind the Bradley House on Main Street. In 1924, he closed both garages and opened a new garage at 21 High Street.

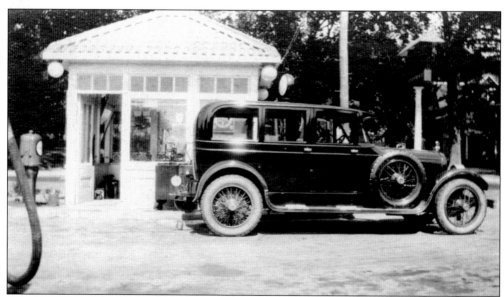

STATION AT 77 MAIN STREET, C. 1928. The Standard Oil Company of New York offered gasoline to a growing number of patrons at its station on Main Street. Pictured here is Harrie Parker's Marmon.

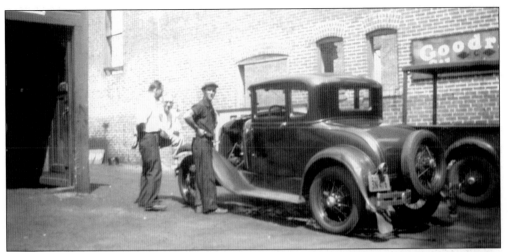

Thomas Rich's Garage. Thomas Rich emigrated from Italy at the age of 15. He worked in a bicycle shop in Waterbury, and in 1896, he opened his own bicycle shop on Bristol Street in Southington. To promote his business he would often sponsor bicycle races, especially on the Fourth of July. When the automobile became popular, Rich opened a garage in the rear of 37 Main Street. Over the years he enlarged the building until in the 1920s he operated the largest garage and dealership in town.

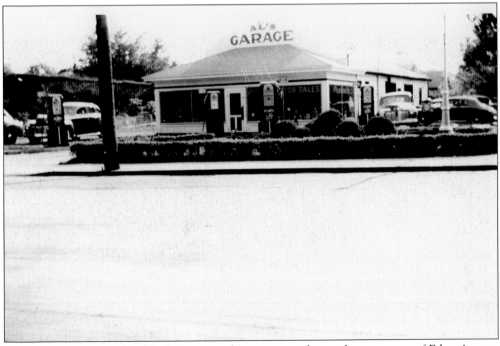

Al's Garage, c. 1935. Al Pipkin operated a garage on the southwest corner of Eden Avenue and Main Street.

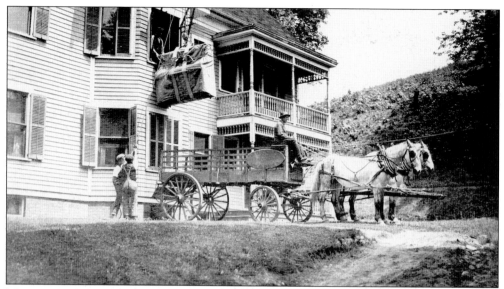

MOVING DAY, C. 1910. James H. Tobin operated a moving company located on Bristol Street near Brook Street. Pictured here, he is moving a piano into 173–175 Main Street. At one time, the house was owned by Sarah Lewis Bushnell, whose husband, Jackson J. Bushnell, was a founder of Beloit College in Wisconsin.

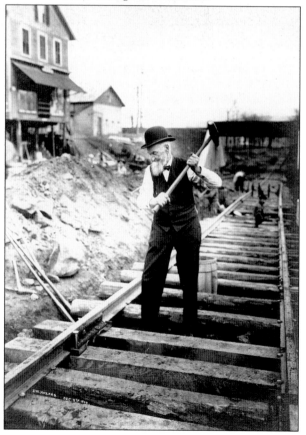

CHARLES H. CLARK DRIVES A SPIKE ON THE GREEN LINE TRAMWAY, DECEMBER 4, 1914. The Green Line tramway that eventually connected Southington with Waterbury had no stronger supporter than Charles H. Clark, who lobbied for the trolley line for years. Already 82 years of age at the time of this photograph, he was president of Clark Brothers' Bolt Company, former president of the Southington National Bank, former member of the Connecticut General Assembly, and a second lieutenant in the 20th Connecticut Regiment during the Civil War. The Green Line project was a difficult undertaking, as it required extensive excavation of the Meriden-Waterbury Turnpike and the creation of an overpass for the existing railroad. The line was completed in 1915 and operated until its demise in the early 1930s.

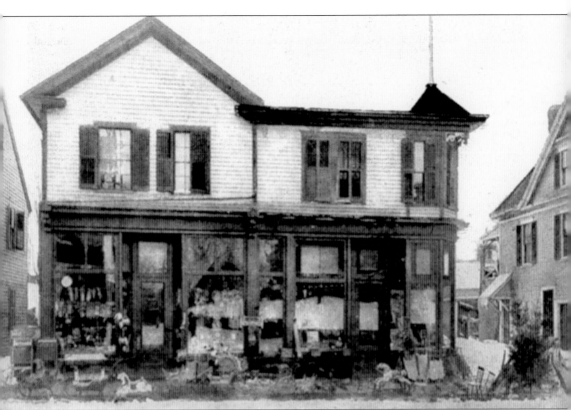

OXLEY'S DEPARTMENT STORE, CENTER STREET. John Oxley was the proprietor of a variety store on Center Street during the later part of the 19th century. He had two sons, Harry and Alfred. Alfred became a successful druggist in town, and Harry became the manager of his parents' store. On July 18, 1898, Harry was arrested here at the store and charged with second-degree murder in the death of his friend Emma Gill. Gill's body was found cut into pieces in Yellow Mill Pond in Bridgeport. During a sensational trial it was discovered that Gill had died at the hands of a "Dr." Nancy Guilford. Harry, on the advice of his attorney, Judge Marcus Holcomb, turned state's evidence and eventually was released from jail. Guilford fled to England but was extradited. She pled guilty to manslaughter and served 10 years in prison. Gill is buried at Oak Hill Cemetery.

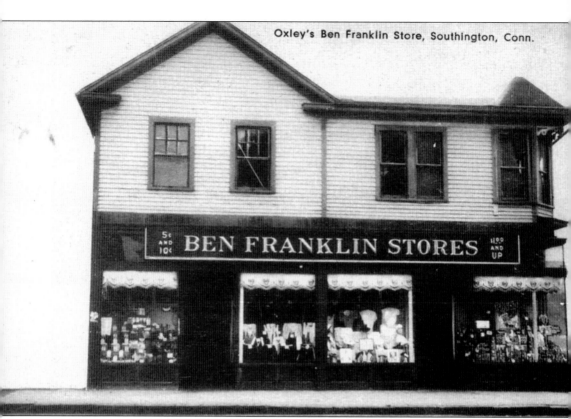

BEN FRANKLIN STORE. Years after the trial, in 1935, Harry Oxley converted his parents' store into a Ben Franklin store. Today the building sits vacant on the corner of Center Place and Center Street.

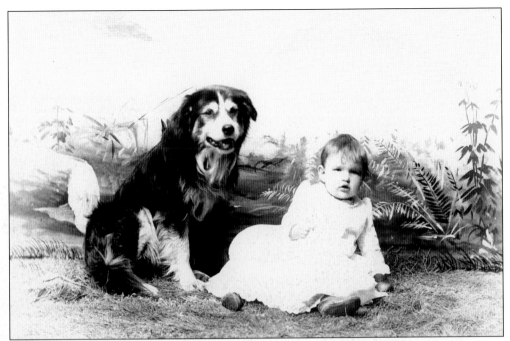

WILHELMINA SCHLAYER AND FRIEND. Shown is one of thousands of portraits photographed by Emerson W. Hazard (1854–1926) at his office at 167 North Main Street. In addition to his studio work, Hazard was known for his panoramic views. For nearly 50 years, he captured Southington with vivid images. Without his portfolio of work much of the town's history would be lost forever.

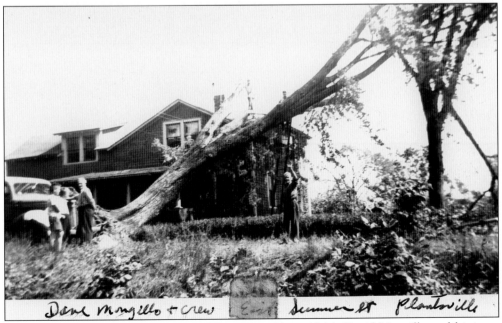

Dave Mongillo + crew East Summer St Plantsville

SOUTHINGTON COAL AND GENERAL TRUCKING, FALL 1944. David Mongillo and his crew remove a tree from a house on East Summer Street in Plantsville.

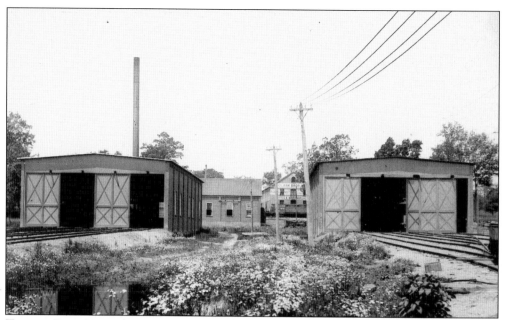

TROLLEY BARNS AND POWERHOUSE, MILLDALE. Completed in 1898, the barns were constructed to house the cars of the Meriden, Southington and Compounce Tramway and were located in the rear of the tramway office on Clark Street. Clark Brothers' Bolt Company can be seen in the distance.

LEVI P. NORTON HOME AND STORE, C. 1885. Although the building is now a private home on West Main Street, at one time in the middle of the 19th century it was a general store owned and operated by Levi Norton (1815–1896) and his wife, Ellen. In 1866, L. V. Walkley borrowed money from his mother and bought an interest in the store. Within four years the annual sales had increased sixfold.

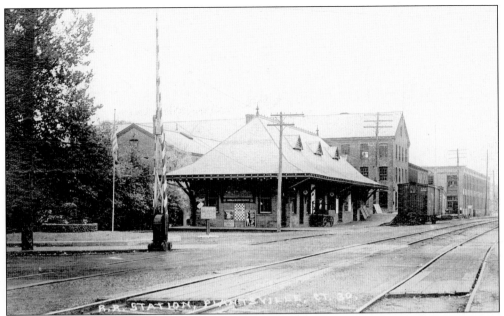

PLANTSVILLE RAILROAD STATION. The New Haven and Northampton Railroad began service to Southington in 1849 with three stops in town, Milldale, Plantsville, and Southington, opposite the Peck, Stow and Wilcox building. In 1874, the railroad decided not to stop in Plantsville but instead build a new depot and station between Plantsville and Southington. This decision enraged the people of Plantsville, who built a new station and demanded that the train stop. It did not. In 1881, the controversy reached the United States Supreme Court in *New Haven and Northampton v. Hamersley* where the citizens of Plantsville were vindicated. The train finally stopped at their station.

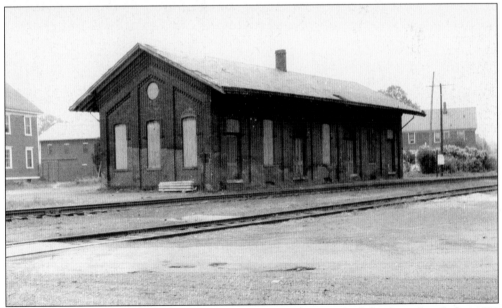

SOUTHINGTON RAILROAD STATION. Pictured is the new station built by the railroad after 1874 for the citizens of Southington and Plantsville.

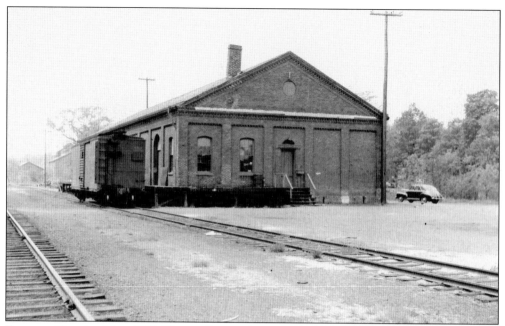

FREIGHT DEPOT. After 1874, Plantsville merchants and industries were expected to use this depot instead of shipping their products from Plantsville. During the late 19th century, their businesses had grown extensively, and they resented bringing their products to Southington for shipment.

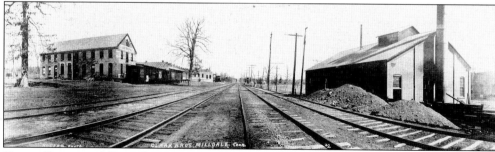

CLARK BROTHERS' BOLT COMPANY, C. 1912. Clark Brothers' Bolt Company was a fixture in Milldale until it closed in the latter part of the 20th century. Founded in 1851 by William J. Clark, who was later joined by his brothers Charles and Henry, the Clark factory manufactured bolts, rivets, and other hardware.

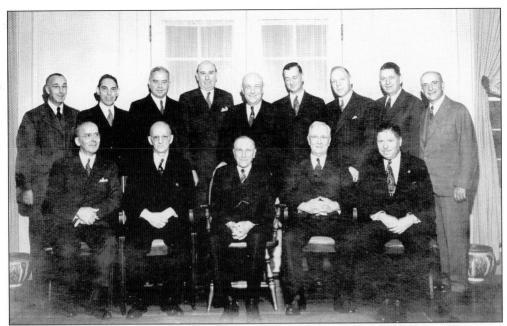

EDWIN TODD'S TESTIMONIAL DINNER. Pictured on October 29, 1942, at the Waterbury Country Club celebrating Edwin Todd's 50 years with the Clark Brothers' Bolt Company are, from left to right, (first row) Oscar Knapp, Charles Smith, Edwin Todd, Thomas Welch, and Rowley Phillips; (second row) James Upson, Otto Reisch, Edwin Northrop, Dewey Blakeslee, Mark J. Lacey, Robert Simpson, Dudley Smith, William Smith, and Warren Williams.

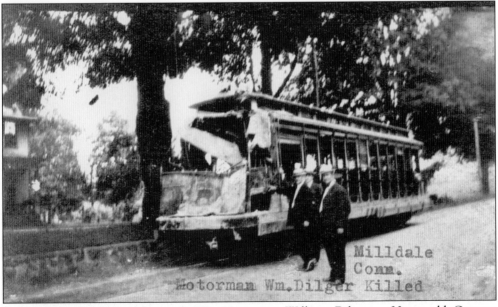

FATAL TROLLEY ACCIDENT, C. 1905. Motorman William Dilger, a 30-year-old German immigrant who lived in Southington, was killed in this trolley accident in Milldale. There were a number of trolley accidents on the Green Line due to the very steep grade down Southington Mountain from Waterbury.

91

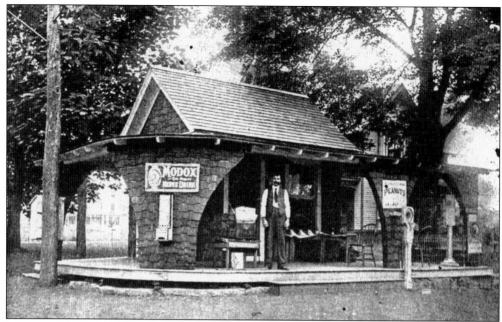

MILLDALE TROLLEY STATION, 1905. Located on the corner of the Meriden-Waterbury Turnpike and Route 10, the trolley station was a popular gathering place where passengers changed trams to proceed to other towns.

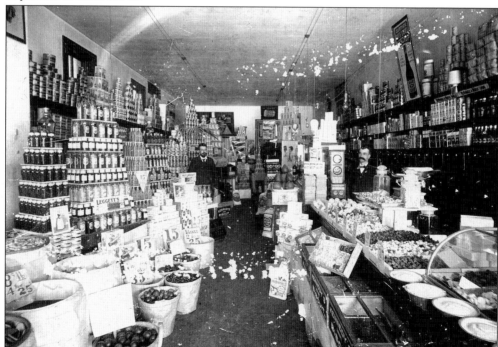

UPSON BROTHERS STORE, C. 1899. From 1884 until they closed in 1912, Frank Upson and his brother William ran a successful grocery business in town. Their father, Andrew Upson, a Yale graduate, was a captain in the 20th Connecticut Regiment when he was killed at Tracy City, Tennessee, on February 19, 1864.

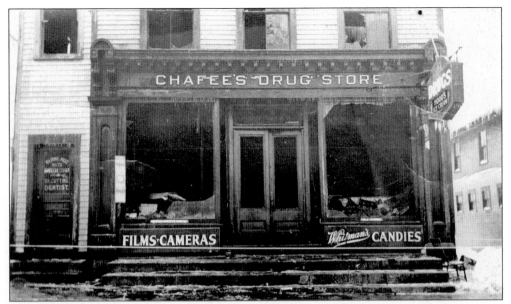

CHAFEE'S DRUG STORE. Chafee's Drug Store, located on the west side of the green, burned on a cold night in December 1935. At the time of the fire, the building also housed the dentist Dr. Armand Cutting and the Kiltonic Post of the American Legion.

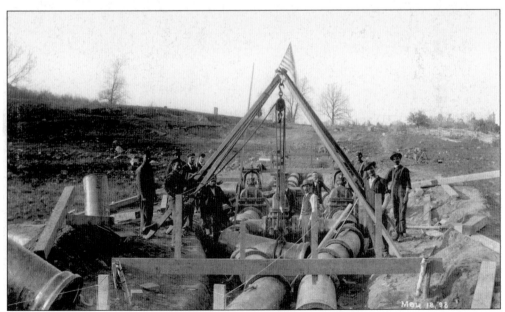

ROARING BROOK PIPELINE, MAY 18, 1898. Pictured are employees of C. W. Snyder and Son working near Queen Street on the Roaring Brook Pipeline to Shuttle Meadow Reservoir. The project was completed on October 1, 1898, at a cost of $293,245.

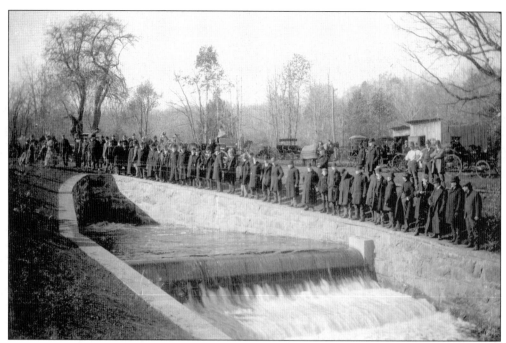

SHUTTLE MEADOW, WINTER 1898. Southington and New Britain residents gather at the southwest corner of Shuttle Meadow Reservoir to watch the first release of water from the Roaring Brook Pipeline into the reservoir. The five miles of 20-inch mains were laid by C. W. Snyder and Son in record time. Southington residents and manufacturers had vehemently opposed New Britain's acquisition of the water rights to Roaring Brook, but the Connecticut General Assembly ignored their pleas and awarded the rights to New Britain.

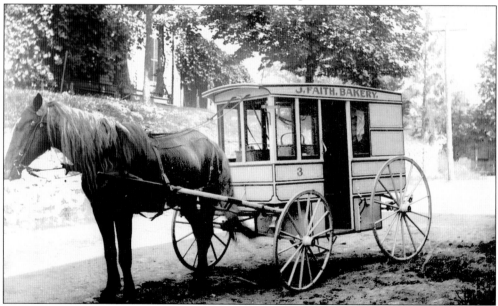

FAITH BAKERY WAGON. Joseph Faith and his sons carried baked goods to stores and individuals in the Southington area. The carriage was twice hit by a tramway car, but both the horse and the driver survived.

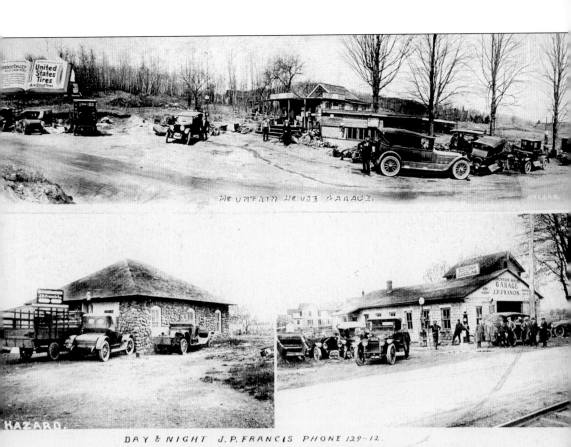

J. P. FRANCIS GARAGE. Pictured are three views of the Mountain House Garage situated on Meriden-Waterbury Road.

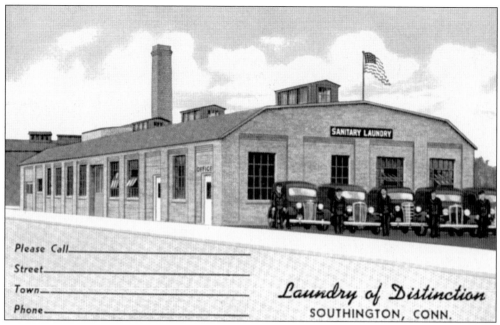

Please Call_____
Street_____
Town_____
Phone_____

Laundry of Distinction
SOUTHINGTON, CONN.

SANITARY LAUNDRY. Dorr Coleman started the Sanitary Laundry behind the Coleman Theater, but later it was sold to Severin Eberhardt and moved to High Street. The laundry closed, but the building remains.

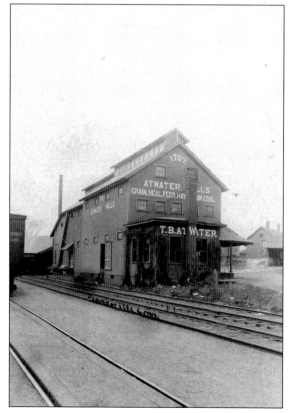

ATWATER MILLS. The original Atwater Mills was located on the east side of the Quinnipiac River across from what would later become the Atwater Manufacturing Company. The mill was started by Capt. Enos Atwater around 1767, and several generations of Atwaters continued to operate the mill. After the original mill was demolished, a new facility, pictured here, was erected near the Plantsville railroad station. Thomas Atwater was the last family member to operate the business, and he sold it after the death of his brother Orville in 1924.

Five

WHO THEY WERE

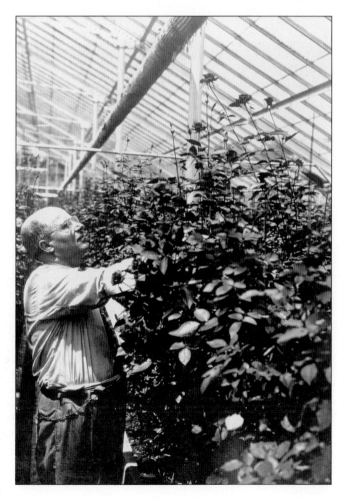

NICHOLAS GRILLO. Pictured here in his greenhouse in 1942, Nicholas Grillo is tending what made him famous, the rose.

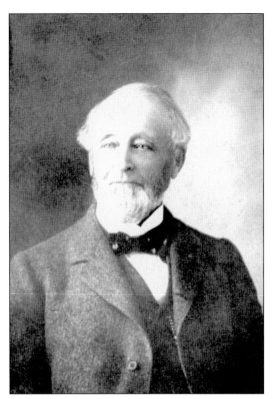

MERIT WOODRUFF. Born in Southington on February 22, 1826, Merit Woodruff began his career with Amon Bradley as a clerk in his store. Eventually he was made a partner in the business. Leaving Bradley in 1865, Woodruff operated a store for two years with Norman Barnes. After a brief retirement, he resumed his career as president of Atwater Manufacturing Company. At the age of 71, while still president of Atwater, he joined Richard Elliott in the real estate and insurance business. He died on December 6, 1911.

THOMAS B. ATWATER. Thomas B. Atwater was a direct descendant of Capt. Enos Atwater, who established the Atwater Gristmill in 1767. Thomas eventually moved the mill near the Plantsville depot and continued as a miller and dealer in grain until he sold the business in 1924.

Amon Bradley. Born in Southington on February 20, 1812, Amon Bradley was in his early years a Yankee peddler who traveled in the South with his wares. After his return to Southington, he served as the postmaster and later as a representative in the Connecticut General Assembly. In 1836, he built the house that is currently the Barnes Museum. Every year, Bradley invested in real estate, amassing a large portfolio of properties. He was married to the former Sylvia Barnes for 67 years. He died on August 20, 1906.

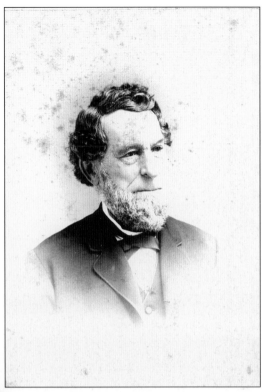

Robert C. Dunham. Robert C. Dunham was born in 1827 on the family farm on the southeastern shore of Shuttle Meadow Reservoir in a house that has long since disappeared. He was for many years the proprietor of the popular Lake House on the shores of Shuttle Meadow. When the City of New Britain forced the resort to close, Dunham returned to farming and in 1885 became one of the founding fathers of the Southington Grange.

CAPT. SAMUEL WOODRUFF. Capt. Samuel Woodruff (1811–1882) was a direct descendant of Samuel Woodruff, the first Colonial settler of Southington. A carpenter by trade, he built many private homes and public buildings in town, including the Plantsville Congregational Church and the old town hall. Woodruff was one of several men who sailed for California during the gold rush. Later, at 51, he volunteered for service in the Union army and was elected captain of the 20th Connecticut Regiment, Company E. During the war, he served at Chancellorsville, Gettysburg, Tracy City, Peach Tree Creek, and the Siege of Atlanta before being honorably discharged on August 28, 1864. Woodruff lived with his wife, the former Emeline Neal, in a house that still stands on Old State Road.

LEILA BARNES, C. 1912. Leila Barnes was the daughter of Frank Upson, owner of a local grocery store. She married Bradley Barnes in a simple ceremony on October 5, 1910, and settled into Amon Bradley's former home that Bradley had enlarged and remodeled for his bride. As was the custom of the day, Leila never worked outside the home but busied herself with gardening and painting. Here she poses in the conservatory surrounded by their collection of exotic plants.

ALFRED OXLEY AND ETHEL HOBART OXLEY, C. 1920. Alfred Oxley, brother of Harry Oxley, was a successful businessman by the time this photograph was taken. His father, John, had run a candy and newspaper store on Center Street. Alfred had pursued a career as a pharmacist first in Putnam and later in Southington at Southworth's Pharmacy, which he purchased in 1900. Later he would purchase several commercial buildings in town. He married Ethel Hobart on September 20, 1904. They lived in a house on the corner of Mill Street and North Main Street that was demolished several years ago.

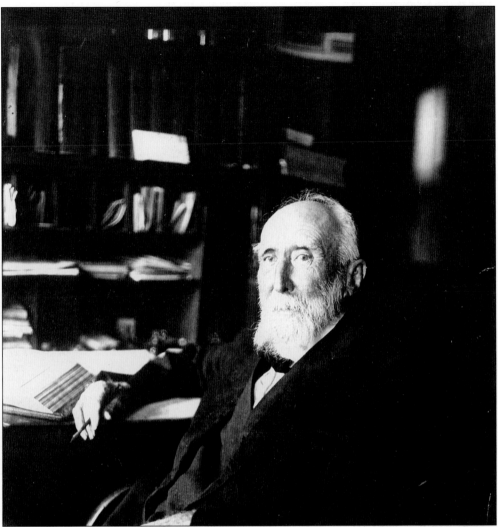

LUMAN ANDREWS. Luman Andrews was the town assessor for many years, but his heart lay in the scientific pursuits of geology, botany, and meteorology. He kept the weather observations for the United States government for over 50 years, he wrote books on the flora of Southington and Meriden, and he was one of the founders of the Southington Grange. Just before his death in 1921, he donated 50,000 botanical specimens and 40,000 mineral and Native American artifacts to the Museum of Natural History in Springfield, Massachusetts.

DR. JAMES H. OSBORNE. Born in Bridgeport on July 12, 1845, Dr. James H. Osborne graduated from the New York Homeopathic Medical College in 1867. He came to Southington and practiced medicine for many years with an office on Center Street. He was the chief engineer of the Southington Fire Department and the health officer in town for 21 years. He died on January 9, 1901.

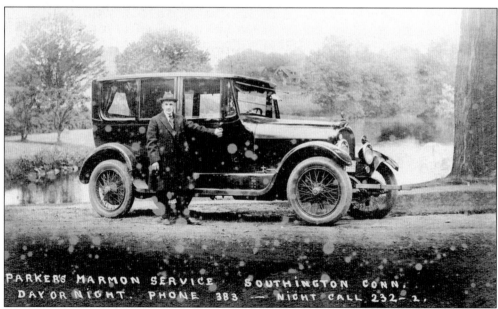

HARRIE PARKER. In his early years, Harrie Parker was a house painter, but he purchased this large black Marmon in the 1920s and opened the town's first taxi service. The Marmon was built in Indianapolis, Indiana, and was a premier vehicle in its day. One could call Parker day or night, and he would drive people to their destinations in style.

CLINTON HAVILAND. Born in Southington on March 19, 1858, Clinton Haviland was the son of Barnes Haviland, the founder of Southington's first newspaper, the *Southington Mirror.* The newspaper business ran in the family and at 20, Clinton purchased the *Southington Reporter* and renamed it the *Southington Phoenix.* Later he purchased the *Bristol Press.* His career was cut short when he died of consumption on November 29, 1892.

SAMUEL McKENZIE, C. 1896. Born in Southington on January 16, 1877, Samuel McKenzie graduated from Lewis High School in 1896 and went on to Huntsinger Business School in Hartford. After a brief stint at Southington Cutlery Company, he joined his father, Theodore McKenzie, as a civil engineer. Later he would become superintendent of the Southington Water Company and guide that department through its early years.

BRADLEY BARNES, 1924. Bradley Barnes was born on January 27, 1883, into a wealthy and influential family. His grandfather owned extensive property in Southington, and his father, Norman Barnes, owned a controlling interest in Atwater Manufacturing Company. Bradley graduated from Lewis High School and the Pequod Business School in Meriden. He went to work for Atwater and by 1910 was the vice president of the company. Although a lifelong Democrat, he vehemently opposed Franklin Delano Roosevelt's programs in the 1930s. When he learned that Roosevelt was an ardent stamp collector like himself, Bradley never collected another stamp. At the time of his death in 1973, the Barnes home and contents were donated to the town as a museum.

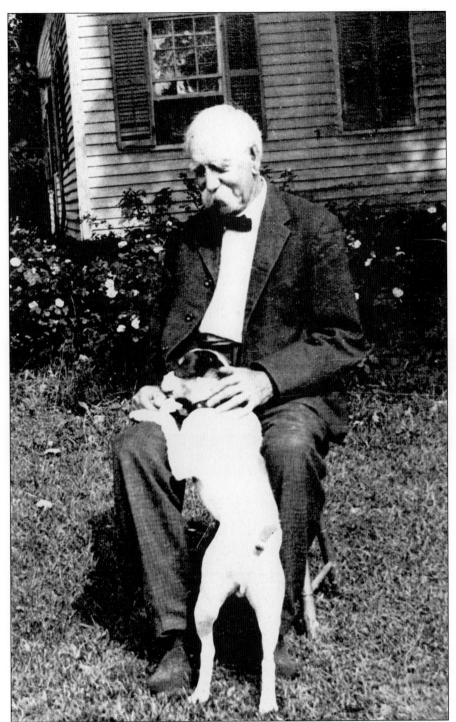

CHARLES MOORE. Charles Moore was born on September 3, 1832, in Kensington. His father, Sheldon Moore, was a 1818 graduate of Yale College. Charles bought the farm on Andrews Street in Southington from Frank Andrews and continued to farm the land until his death in 1913. He is pictured here with his dog in front of his home in the later years of his life.

LEAVING
ROCHESTER

March 20th 1916

JULIAN FLORIAN AND EMILY TOLLES FLORIAN. Julian Florian, a graduate of Cornell University, was a brilliant industrial chemist who in 1903 invented an emulsion formula that allowed the development of photographs without the use of a negative. In 1907, Florian incorporated this formula into a photograph machine that he designed and built. Installing the machines in Coney Island, Luna Park, Lake Compounce, and other public places, they were an instant success. Then residing in Plantsville, Florian began the production of these machines. In 1929, Eastman Kodak purchased the formula, and Florian collected royalties from Kodak until 1934. The Florian Studios continued to manufacture and sell the photograph machine through the 1930s. Anyone who has ever stepped inside the booth of one of these machines owes that experience to Julian Florian.

Six

CELEBRATIONS AND OBSERVATIONS

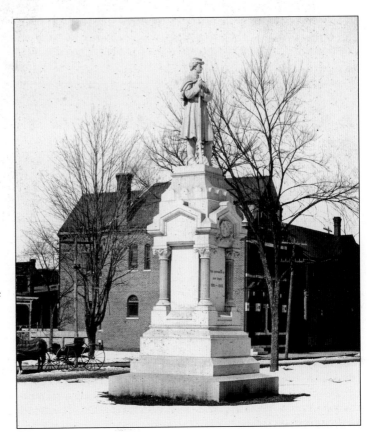

SOLDIERS MONUMENT.
Designed by Charles
Conrad and fabricated by
the New England Granite
Works, the Civil War
monument was dedicated
on the green on
August 18, 1880. Nearly
3,000 people turned out,
including contingents
from the GAR in
Meriden, New Britain,
and Southington.

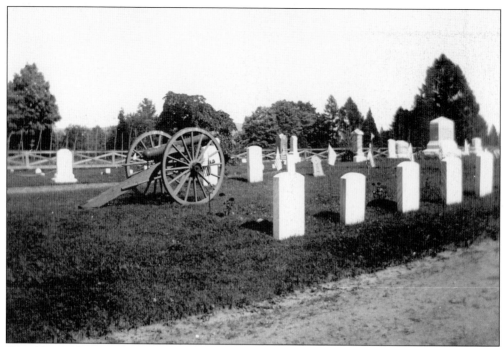

QUINNIPIAC CEMETERY, C. 1890. After the Civil War, the Quinnipiac Cemetery Association set aside a section in the northeast corner of the cemetery for the Civil War soldiers. At the time this picture was taken, 11 markers were in place, including those of Horace Tolles, killed at Bermuda Hundred, Virginia, and Luzerne Norton, killed at Chancellorsville, Virginia. The cannon, a part of the site for many years, was stolen one night. The wooden fence was replaced in 1922 by a fieldstone wall given by Flora Clark Smith in memory of her parents, Henry Clark and Susan Curtiss Clark. On May 13, 1917, thousands gathered to witness a parade and a memorial service at the cemetery where Flora Frost, great-granddaughter of Civil War soldier Hurbert Bailey, unveiled 31 government-issued marble markers commemorating those who left Southington to serve in the Civil War and never returned.

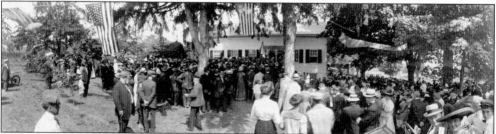

DEDICATION OF THE ROCHAMBEAU MONUMENT, JUNE 30, 1912. Over 1,000 people gathered on the lawn of the Munger Farm in the village of Marion on the afternoon of June 30, 1912, to witness the dedication of the Rochambeau Monument. Lieutenant General Rochambeau and his French troops camped at the site on their way to and from the Battle at Yorktown. The campaign to provide the monument was spearheaded by Capt. Lawrence O'Brien and Dennis Tierney, both members of the Irish American Historical Society based in Providence, Rhode Island. James K. Kelley of New York City designed the monument. On the day of the festivities, the Boys Orchestra of Ansonia provided the music with speeches given by Gov. Simeon Baldwin of Connecticut; Viscount DeJean, first secretary of the French embassy; Judge John Walsh of New Britain; and Thomas Holt, first selectman of Southington.

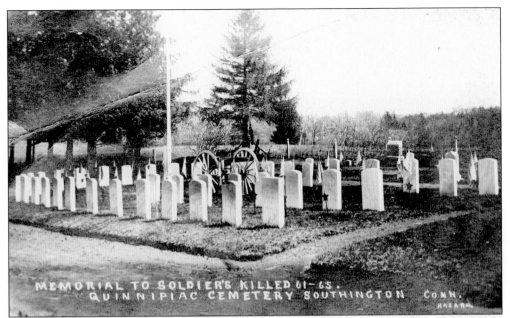

QUINNIPIAC CEMETERY. This photograph was taken after the 1917 unveiling of the 31 new markers that completed the Civil War section of the cemetery.

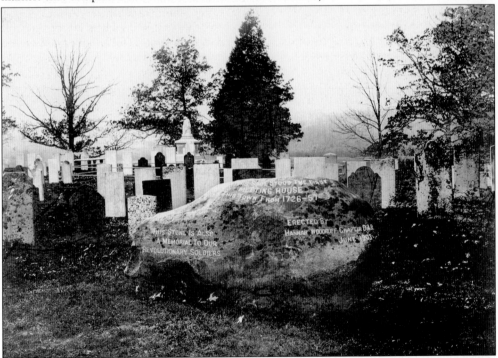

THE FIRST MEETINGHOUSE. On June 4, 1903, the Hannah Woodruff Chapter of the DAR dedicated a plaque on a boulder donated by Martin Frisbee in Oak Hill Cemetery that marked the site of the first meetinghouse. Master Kenneth Curtis gave the presentation speech, and Caroline Cowles accepted the monument on behalf of the town. A reception followed the ceremony at the Red Men's hall.

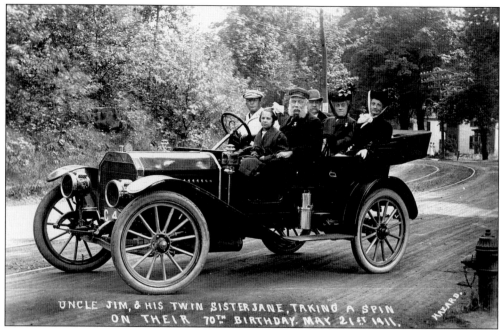

Uncle Jim, & his twin sister Jane, taking a spin on their 70th birthday. May 21st 1911.

GAR MEMBER AND FAMILY GO FOR A RIDE. James V. Johnson and his twin sister, Jane Johnson Heathcote, go for an automobile ride on May 21, 1911, just before celebrating their 70th birthday with 100 friends at the Red Men's hall. Johnson served in the 20th Connecticut Regiment, Company E, during the Civil War. He was wounded on May 3, 1863, at Chancellorsville but survived his wounds and was mustered out in 1865.

MEMORIAL DAY, MAY 30, 1914. Pictured are members of the Women's Relief Corps who followed the GAR and members of the Sons of Veterans in a parade from High Street to the Soldiers Monument on the green. After the laying of wreaths, Dr. John Brown Focht, pastor of the Plantsville Congregational Church, gave the address to the assembled crowd.

DECORATION DAY, MAY 31, 1912. Civil War veterans gather for a memorial service on the town green.

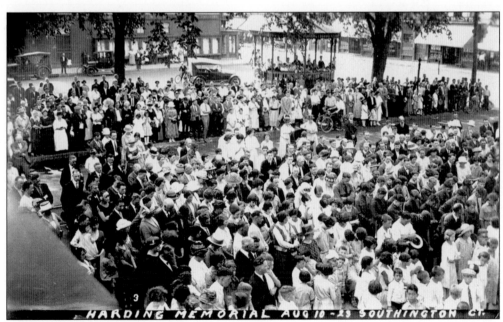

MEMORIAL SERVICE. Crowds gather on the town green for a memorial service for Pres. Warren G. Harding in August 1923.

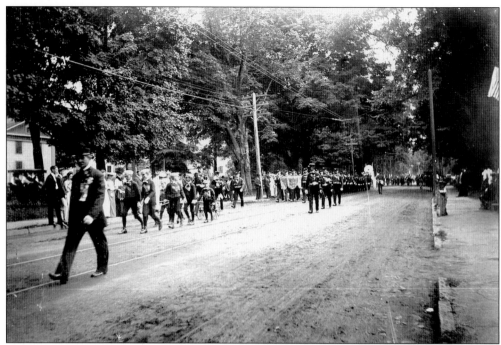

FIREMAN'S PARADE, SEPTEMBER 2, 1903. Five thousand spectators lined the seven-mile route to see the Southington Fire Department, 30 other Connecticut fire companies, and 24 bands parade through the town. The day was so hot that many of the men could not finish the parade.

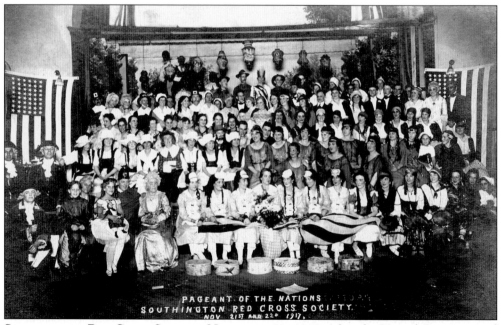

SOUTHINGTON RED CROSS SOCIETY, NOVEMBER 21, 1917. After the United States entered World War I, the Red Cross staged many events like this one to increase membership and help raise money for the war effort.

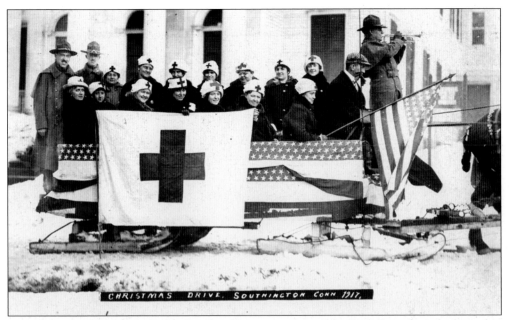

SOUTHINGTON RED CROSS. During the Christmas season, the Red Cross launched another fund-raising drive with the sale of Red Cross banners. On Christmas Eve, as planned, everyone hung the crosses in their windows and lit them from behind. It was reported to be a spectacular sight.

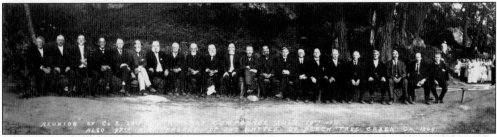

THE 20TH CONNECTICUT REGIMENT, COMPANY E. Every year the surviving members of the company gathered for a reunion with the remaining members of their ranks. The majority of this company was composed of Southington men under the command of Capt. Samuel Woodruff. They are pictured here enjoying the day at Lake Compounce.

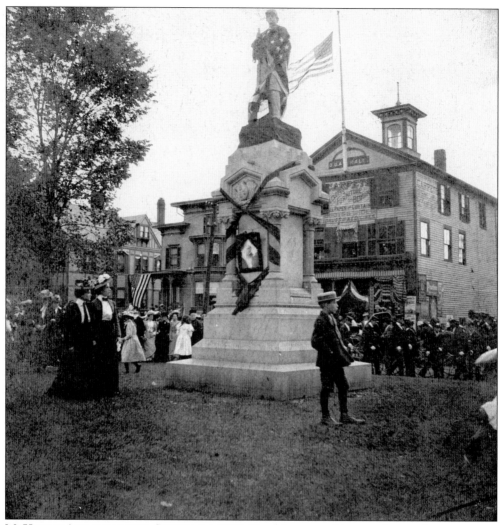

MᴄKɪɴʟᴇʏ Aꜱꜱᴀꜱꜱɪɴᴀᴛɪᴏɴ, Sᴇᴘᴛᴇᴍʙᴇʀ 1901. Southington residents gather on the town green to mourn the loss of Pres. William McKinley.

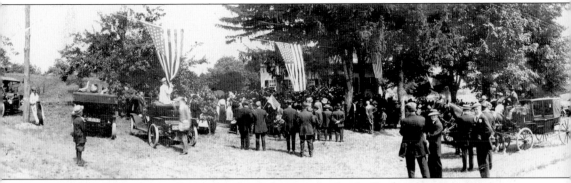

ROCHAMBEAU MONUMENT. Pictured is the dedication day for the Rochambeau Monument.

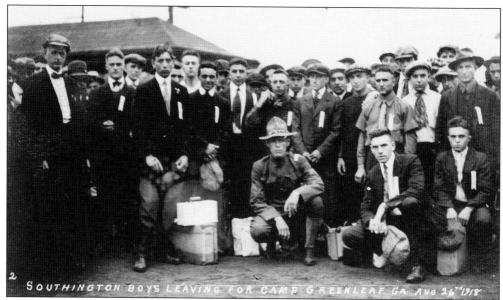

WORLD WAR I. On August 26, 1918, Southington recruits pose for a picture before boarding the train for Camp Greenleaf, Georgia. A total of 425 men from Southington eventually served in the war.

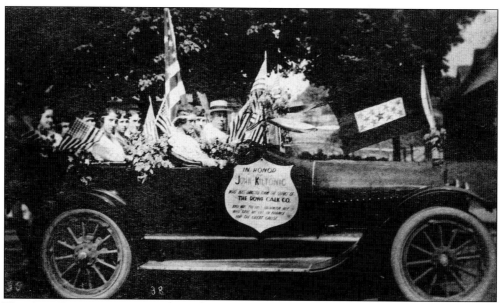

KILTONIC POST, AMERICAN LEGION CAR. John Kiltonic was the only Southington casualty of World War I. The local post of the American Legion was named in his memory. Formed in 1919, the Kiltonic Post originally met in the hall above Oxley's Drug Store but later moved to the rooms over the Coleman Theater on Main Street. After several fund-raisers and generous donations from the citizens of Southington, the veterans' group was able to purchase the building on the west side of the green from the Neal estate. After much remodeling, the Kiltonic Post moved into the hall and remained there until the building burned in 1935. The Kiltonic Post now occupies a brick building on this site.

Seven

FARMSTEADS

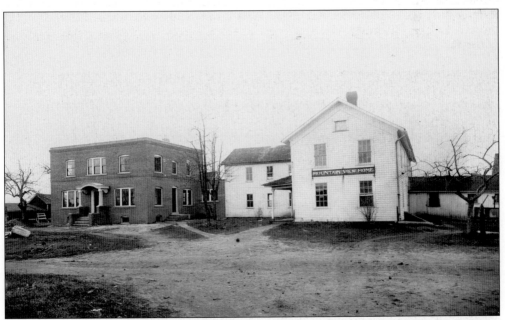

MOUNTAIN VIEW FARM AND ALMSHOUSE, C. 1913. On January 13, 1852, the Town of Southington purchased 63 acres of land with a dwelling house from James Tyler. The town converted this property into a farm and home for those citizens who had nowhere else to live. Indigents who arrived in town were taken to the farm where they received a meal in exchange for chopping wood. By 1912, the farmhouse was inadequate for the number of residents and offered no indoor plumbing. At a town meeting, it was voted to spend $5,000 to build the brick superintendent's cottage that housed a kitchen, dining room, and quarters for the staff. Anthony A. Boyce was the general contractor, and William Ballou installed the plumbing and heating. The home and farm survived the social programs of Franklin Delano Roosevelt and those of Lyndon Johnson and did not close until 1968 when the remaining five residents were moved elsewhere.

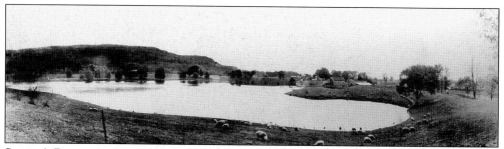

SLOPER'S POND, C. 1900. Settled by Capt. Ambrose Sloper (1734–1822) and his wife, the former Sarah Root, the farm remained in the family for generations. This photograph by Emerson W. Hazard illustrates the deforestation of Connecticut in the early years of the 20th century. In the distance is the Sloper homestead, and on the pond is the barn where the harvested ice was stored.

JOSIAH MERRIMAN, C. 1890. Pictured in front of their home at the southern end of Shuttle Meadow Reservoir are Josiah Merriman and his wife, the former Anna Curtiss. Josiah's father, Anson Merriman, had purchased the house from Amasa Evans in 1832. Josiah's daughter Sarah married Elijah Rogers, and eventually the two orchards merged.

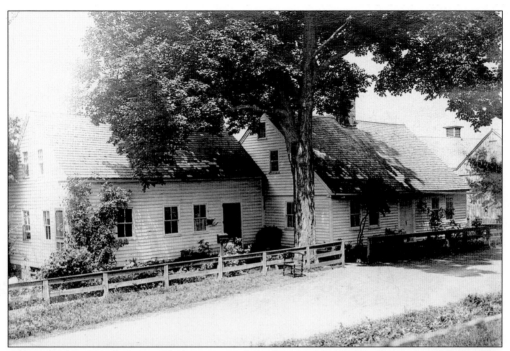

CLARK FARMS, 1895. James Clark was one of the first settlers of New Haven in 1638. By 1720, his descendent Samuel Clark (1673–1754) had settled in the southeast part of the town on what is today Meriden Avenue. The area of the town has always been known as Clark Farms.

ELIJAH ROGERS'S BARN. This barn near Shuttle Meadow Reservoir is now the salesroom for Rogers' Orchards.

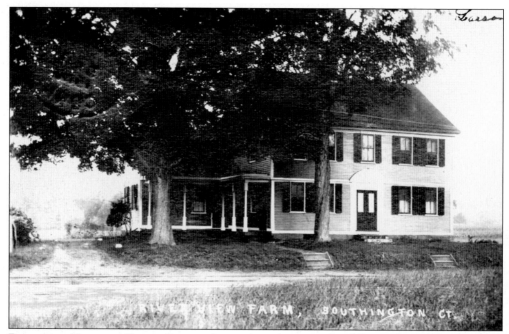

RIVERVIEW FARM ON QUEEN STREET. Located on the west side of Queen Street, this was most recently known as the Larson Farm. It was the last of the 18th-century homes to disappear on Queen Street.

ELIJAH ROGERS FARM. Elijah Rogers was born in Simsbury in 1841. In 1888, he came to Southington and purchased a farm from Horatio Dunham located at the west end of Shuttle Meadow Reservoir. At first Rogers devoted himself mainly to dairy farming, but by 1921, he converted all the land to orchards. With his marriage to Sarah Merriman, whose father was also engaged in fruit farming, his farm eventually became the largest apple grower in Connecticut.

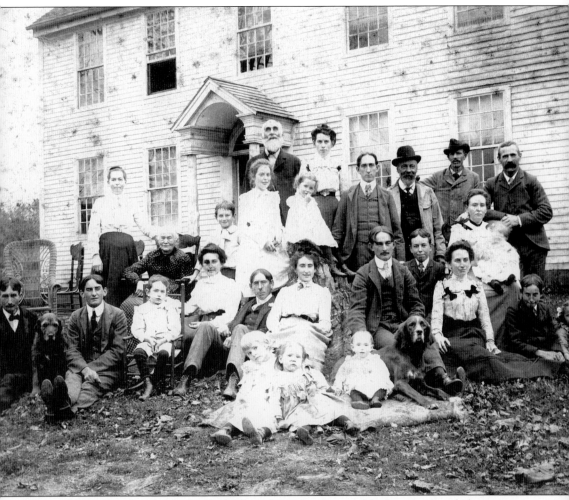

SMITH FARM. Dwight Smith (1847–1926) and his family stand before the Smith house on Andrews Street. Smith was married to Edith Emily Rogers and after her death married her sister Elizabeth. Smith fathered 17 children, some of whom are pictured here.

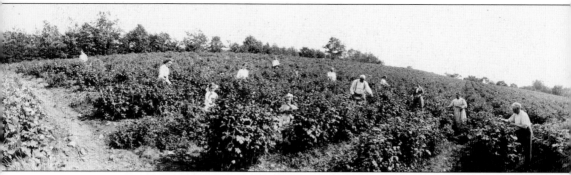

RASPBERRY PICKING. Before Wassil Reservoir was created on Andrews Street, the Smiths maintained a large berry farm on the site.

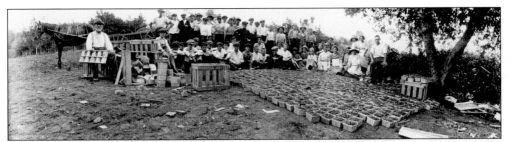

RASPBERRY HARVEST. Dwight Smith poses with his crew of helpers before an abundant harvest on the Smith farm on Andrews Street.

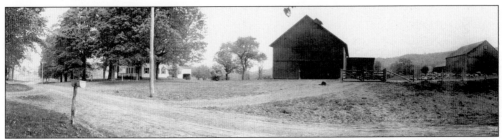

THE LEO OTT FARM, C. 1910. At one time Queen Street, now lined with commercial development, was dotted with farms. Leo Ott's farm was located just south of the old Pratt and Whitney plant.

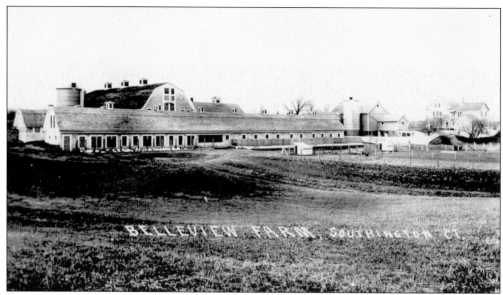

BELLVIEW FARM. L. V. Walkley was the owner of this farm once located in what is today a residential area centered around Belleview Avenue. Walkley claimed that he never made any money from this enterprise, but he seemed to have fun for a time with the farm. In the fall of 1917, he won several first-place prizes at the National Dairy Show in Ohio. In 1918, he sold a Jersey cow named Gamboge Oxford Gem for a record price of $18,000. In 1921, he paid $65,000 for a bull named Sybil's Gamboge, another auction record at the time. Eventually he sold the farm for development.

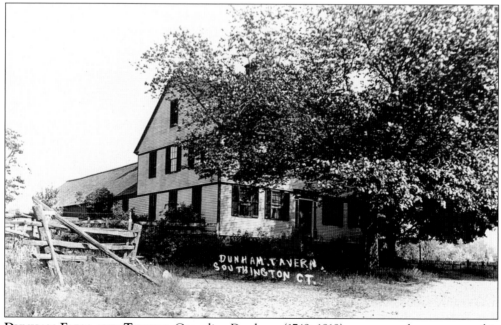

DUNHAM FARM AND TAVERN. Cornelius Dunham (1749–1818) ran a popular tavern on his farm on the north end of Queen Street.

HAROLD ROGERS'S HOUSE. Pictured on the left-hand side of the photograph is the home built for Harold Rogers around 1919. The view offers a sweeping panorama of the orchards and the reservoir.

THE FARMS AT SHUTTLE MEADOW. The farm and barns on the right of the photograph are those of Elijah Rogers. The farmhouse and barns on the left, like most of the Southington farmsteads, have long since disappeared.

Across America, People are Discovering Something Wonderful. Their Heritage.

Arcadia Publishing is the leading local history publisher in the United States. With more than 3,000 titles in print and hundreds of new titles released every year, Arcadia has extensive specialized experience chronicling the history of communities and celebrating America's hidden stories, bringing to life the people, places, and events from the past. To discover the history of other communities across the nation, please visit:

www.arcadiapublishing.com

Customized search tools allow you to find regional history books about the town where you grew up, the cities where your friends and family live, the town where your parents met, or even that retirement spot you've been dreaming about.